Bridgeport
1900–1960

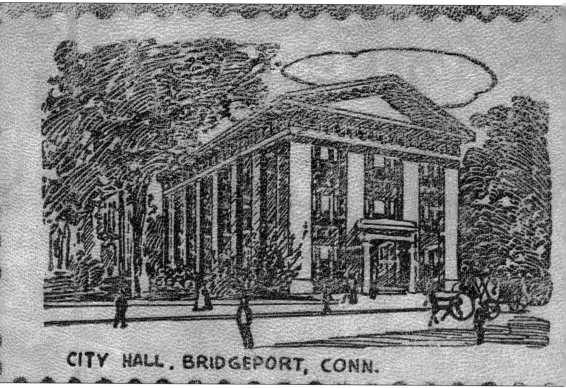

CITY HALL, BRIDGEPORT, CONN.

This real leather postcard has an image of the Bridgeport City Hall imprinted on it. Over the years, this building has also been used as a courthouse, a police station, and a jail. This brownstone building resembling a Greek temple was built in 1853 and is still being used today for city offices, including the registrars of voters and the office of vital statistics. Leather postcards such as this were banned by the postal service in 1909.

On the front cover: A tranquil harbor scene is evident on this postcard published by the Illustrated Postal Card Company of New York around 1911. It also printed the exact same scene with a sunset sky, a moonlight sky, as well as the blue sky shown here. (Author's collection.)

On the back cover: Postmarked in 1909, this embossed postcard is considered to be of the generic variety. The publisher used the same photograph and only had to change the name of the city and state to be able to sell the card in different parts of the country. (Author's collection.)

POSTCARD HISTORY SERIES

Bridgeport
1900–1960

Andrew Pehanick

ARCADIA
PUBLISHING

Published by Arcadia Publishing
Charleston SC, Chicago IL, Portsmouth NH, San Francisco CA

Printed in the United States of America

Library of Congress Catalog Card Number: 2008931748

For all general information contact Arcadia Publishing at:
Telephone 843-853-2070
Fax 843-853-0044
E-mail sales@arcadiapublishing.com
For customer service and orders:
Toll-Free 1-888-313-2665

Visit us on the Internet at www.arcadiapublishing.com

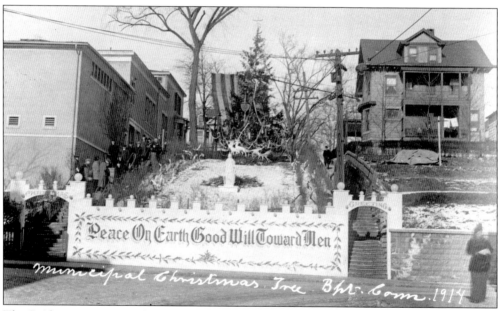

The Bridgeport Municipal Christmas tree is shown in this real-photo postcard taken from Broad Street and Elm Street in 1914. At that time, the Broad Street steps were twin sets of stairs separated by a green in the middle. The former Alfred Bishop house, which fronted on Golden Hill Street, is on the left. The University Club, which occupied the building at this time, put the addition seen on the left on the back of the house that contained their indoor squash courts. The house on the right is still standing.

CONTENTS

Acknowledgments

I would like to offer my thanks to Joanne Powers, Mary Cioffi, Odis Fisher, Robert Mullaney, and Mary Yankowski for their inspiration and generous help with the preparation for this book.

I also want to thank the following people for their much-needed help in researching the information in the book: Al Dunbar, Grace Tiranti, William Callan, Geoff Wargo, and especially Charles Brilvitch. A special thanks to Mary K. Witkowski, Sarah Greenberg, and Elizabeth Van Tuyl in the historical collections department of the Bridgeport Public Library.

The following individuals have been important sources of postcards for my collection: Ove Braskerud, Dave Williams, Tom Mills, Robert L. Berthelson, Kurt Hilzinger, John Skutel, Vinny Ingrassia, Harry Ruppenicker Jr., and Jimmy Guglielmo.

Thanks are also extended to John Daly of the University of Bridgeport, Lorraine Bukowski of Aquarion, Fred Fleischer at the Barnum Museum, and all the members of the Bridgeport Community Historical Society.

This book is dedicated to my mother, Helen Lerose Pehanick (1921–1997).

INTRODUCTION

The reason for a second postcard history book on the city of Bridgeport is to present additional views previously omitted, owing to space limitations. There are two postcards that are included in both books for a reason. I wanted to clarify the information previously given, and also, these cards fit right in with this book. Once again, all the images contained in this work are postcards, and they are all from my collection.

The University of Bridgeport was chosen for the first chapter because of my interest in the many grand old mansions that were built in the south end of Bridgeport bordering Seaside Park. The next chapter illustrates the changes that took place along Main Street downtown over the years. The chapter on transportation was fun to work on and also reflects my interest in old cars and aircraft as well. A chapter on Bridgeport harbor must be included because of the important role the harbor has played in the development of the city. The advertising postcards are very imaginative, and the result was a very diverse chapter. Mechanical cards really have to be opened up to be appreciated, so the chapter does not really do them justice. However, the multiple-view postcards have a lot of information that is shown on a single card. My interest in the mansions that once graced the city of Bridgeport is shown once more with the chapter on notable residences. The chapter on restaurants and recreation was my favorite chapter to work on because it gave me an excuse to dine at some nice restaurants in the name of research. In the last chapter, I was able to include postcards that did not fit in anywhere else but still made an interesting chapter, since bird's-eye views do show a lot of detail.

I hope that you enjoy *Bridgeport: 1900–1960* as much as the first *Bridgeport* postcard book.

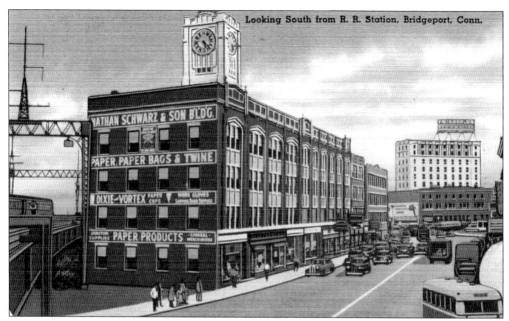

A postcard looking south on Water Street from Fairfield Avenue shows how this area looked in the 1940s. Nathan Schwartz and Son occupied the building with the clock tower between the railroad tracks and Water Street. Schwartz was also the publisher of this postcard. Water Street has since been widened, and there are no longer any buildings between the street and the railroad tracks.

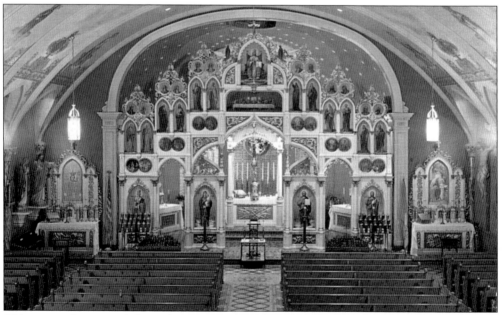

This postcard was a gift from the author's father of St. John the Baptist Greek Rite Catholic Church when it was located at 717 Arctic Street. The beautiful floor-to-ceiling iconostasis or icon screen is evident in the richly detailed interior of the church. This postcard marked the occasion of the rededication of the church on October 13, 1957. The church congregation, now located in Trumbull, has recently celebrated its 100th anniversary.

8

One

THE UNIVERSITY OF BRIDGEPORT

The University of Bridgeport was founded in 1927 as the Junior College of Connecticut. The first home of the new college was a mansion located at 1001 Fairfield Avenue. In 1940, P. T. Barnum's former estate Marina was purchased, which gave the college room to expand. The tack-up pennant shown here was mailed in 1952.

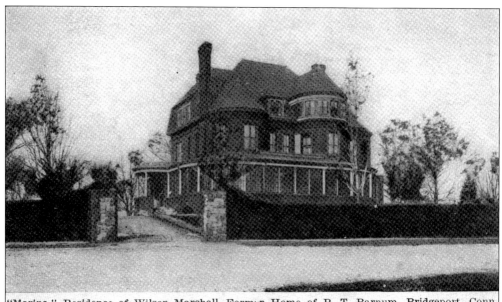

"Marina," Residence of Wilson Marshall, Former Home of P. T. Barnum, Bridgeport, Conn

Marina was the name P. T. Barnum gave to his fourth and final Bridgeport home. Built in 1889 for his second wife, Nancy, Barnum died here in his bedroom two years later. Marina was occupied afterward by his son-in-law Wilson Marshall. Although purchased by the university in 1940, it was first rented out to the Red Cross during World War II.

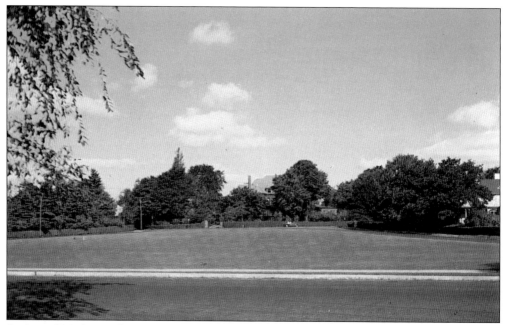

A view of Marina Park is seen in the foreground of this 1950s–era postcard. In the center is the Marina mansion, which is mostly hidden by trees. Barnum gave Marina Park to the city with the stipulation that no buildings could ever be built on the land that would block the view of Seaside Park from the mansion.

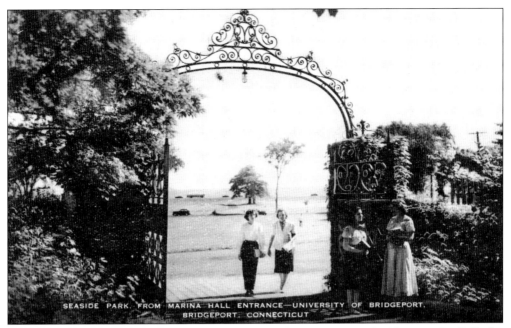

In 1947, the Junior College of Connecticut became the University of Bridgeport. In 1949, the Fairfield Avenue campus was sold, and the consolidation and move to the seaside campus was completed. Shown here is a postcard view of Marina Park and Seaside Park framed by the ornate entrance gate to the Marina estate.

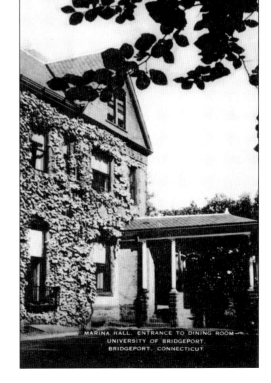

The ivy-covered walls of Marina and the entrance gate to the estate are highlighted in this postcard view. In 1946, Marina was used as a residence hall and was later used primarily as a dining hall. Sadly, this 17-bedroom mansion with nine baths was torn down in 1961, and a new dining hall also named Marina was built in its place.

11

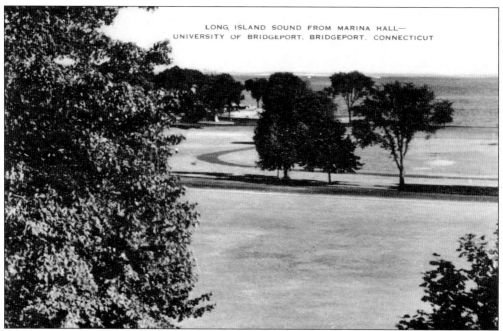

A beautiful view of Seaside Park and Long Island Sound is seen here from an upstairs window of the Marina mansion. P. T. Barnum was instrumental in the creation of Seaside Park and enjoyed this same view many years earlier.

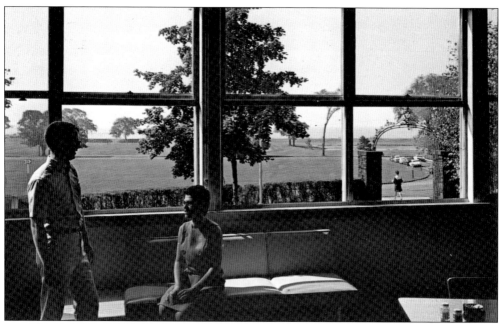

A couple of students take a break and relax inside the newly completed Marina dining hall. Seen through the lower window on the right are brick pillars with a wrought-iron archway above them. These pillars are all that remain of Barnum's Marina estate.

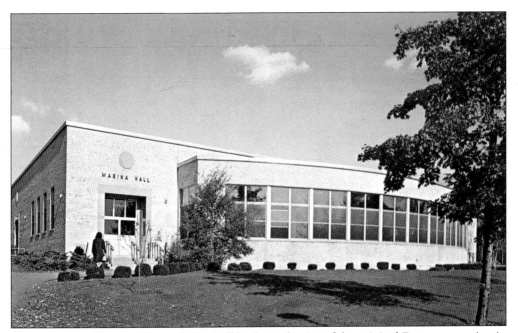

Shown here is the new Marina dining hall built on the site of the original Barnum mansion in 1961. This was built as a large wing added to an existing building constructed earlier in 1957, which was attached to the back of the Marina mansion. Also built on the grounds of the original six-acre Marina estate in 1957 were Cooper and Chaffee residence halls.

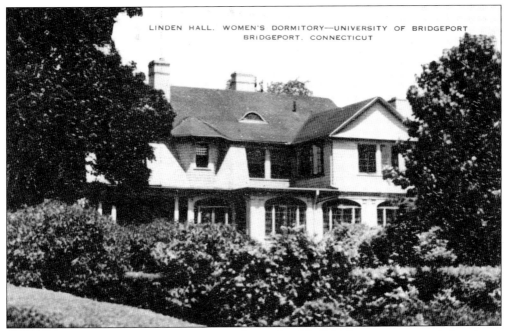

Linden Hall was acquired by the university on September 30, 1947, for use as a women's dormitory. Built in 1892, the original owners were Charles Barnum Read and his wife, Eleanor. Read was the son of P. T. Barnum's half-brother Philo. This unusual shingle-style cottage is still standing at 66 Marina Park Circle near the southeast corner of Waldemere Avenue.

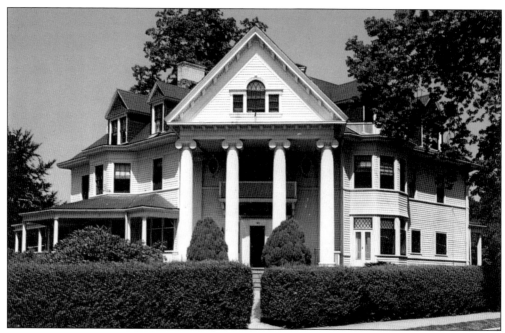

Beautiful Seaside Hall was built around 1910 as the residence of Dr. Virgil Gibney and stood at 352 Waldemere Avenue on the southwest corner of Marina Park Circle. This grand Georgian Colonial facing Seaside Park was purchased from Gibney family heirs on June 29, 1946.

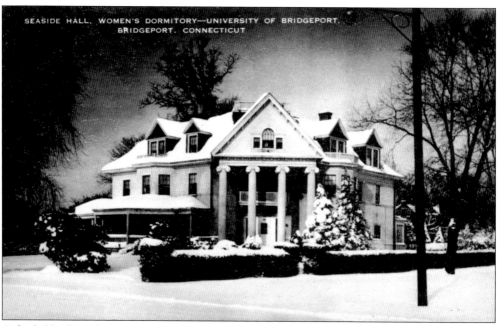

A fresh blanket of snow surrounds Seaside Hall in this postcard view from the 1950s. This mansion was used as a women's dormitory for a number of years. In 1962, it was torn down to build the Barnum Residence Hall. The Seeley Residence Hall was also built on the same property near Ingleside Place.

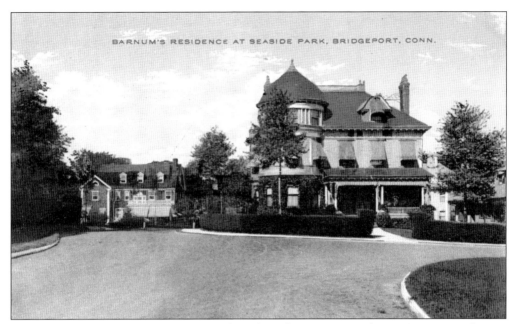

On the Southeast corner of Marina Park and Linden Avenue is the Levi W. Eaton house, mistakenly identified here as belonging to Barnum. Eaton was president of the Bryant Electric Company and built this residence in 1893. The university acquired the house from his widow in 1959 for use as a residence hall. This house, as well as the one shown on the left at 115 Park Avenue, is still standing today.

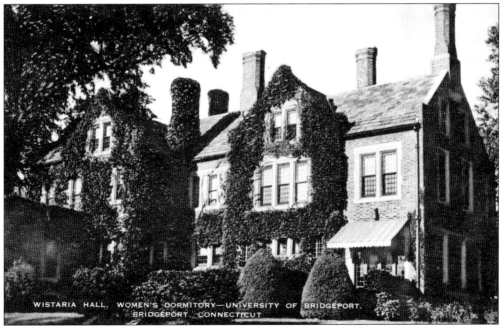

Wistaria Hall, built in 1915, was originally the residence of Dudley Morris who later built a larger mansion in Black Rock known as the Chimney's. The university purchased this 14-room English Tudor mansion on September 30, 1947, for use as a women's dormitory. This brick mansion is still standing at 105 Linden Avenue on the northwest corner of Ingleside Place.

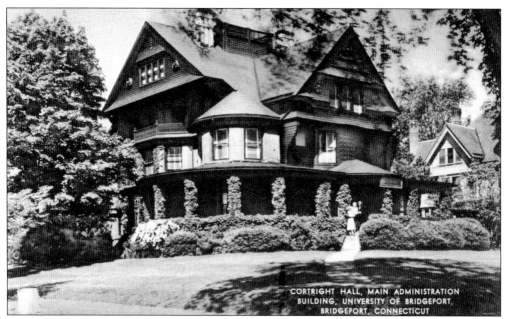

Cortright Hall was built in 1890 by Lavina L. Parmly as a wedding present for her grandson Parmly S. Clapp. This 10,000 square foot shingle-style mansion was used as a summer residence. Later purchased by Allen W. Paige, the house was given to the university by his widow, Elizabeth, as a gift in 1950.

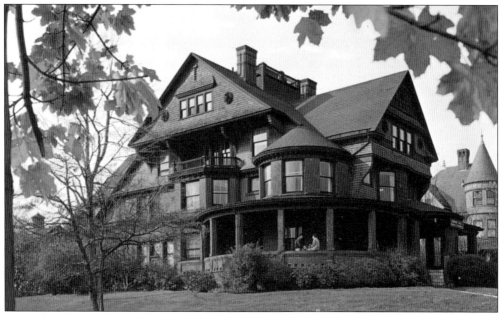

Located on the northwest corner of Park Avenue and University Avenue, Cortright Hall is named after E. Everett Cortright, who was the first president of the Junior College of Connecticut and was instrumental in the founding of the college. Originally used to house the office of the president and top administrators, it is today home to the Department of Public Relations. On the right is the George Comstock house built in 1887, which is no longer standing.

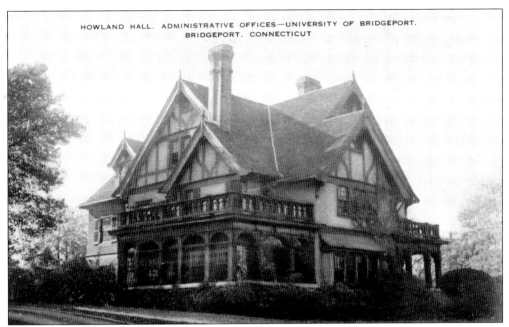

HOWLAND HALL. ADMINISTRATIVE OFFICES—UNIVERSITY OF BRIDGEPORT.
BRIDGEPORT, CONNECTICUT

On the southwest corner of Park Avenue and Atlantic Street stands the John G. Howland house, built in 1902. Howland was the president of the Howland Dry Goods Company in Bridgeport and lived in this English Tudor–style house until 1947. In 1949, it became a part of the University of Bridgeport campus and is still standing today.

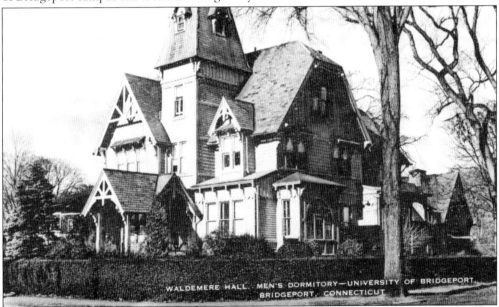

WALDEMERE HALL. MEN'S DORMITORY—UNIVERSITY OF BRIDGEPORT.
BRIDGEPORT, CONNECTICUT

Waldemere Hall was built in 1883 and was located at 110 Waldemere Avenue on the northwest corner of Hazel Street. It was the former home of John King, a prominent state and national political leader for many years. Local tradition says that the decision to nominate Theodore Roosevelt for the vice presidency was made in this home. This multi-gabled gingerbread mansion, purchased by the university in 1947, was used as a men's dormitory. The house was torn down in 1955 for the construction of the Harvey Hubbell Gymnasium.

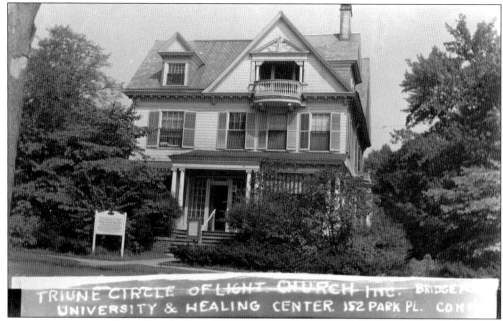

Trumbull Hall was built in 1897 and was located at 152 Park Place. This was the former home of William Thurston Hincks, the E. P. Bullard family, and the Triune Circle of Light Church. This 17-room mansion was acquired by the university on August 16, 1949, for use as a dormitory. The site, once opposite Hazel Street, is presently used for parking.

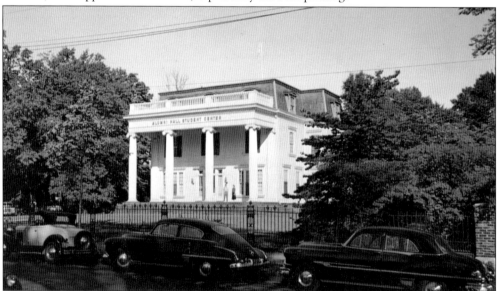

George Mallory built this 20-room mansion on what was known as South Street in 1867. His farmland surrounding this house was later divided into lots and streets as the south end of the city began to grow after Seaside Park was built. This house, named Loyola Hall, was eventually acquired by the university from Fairfield College Preparatory School and was renovated into the Alumni Hall in 1953. This mansion, located at 200 Park Place, was destroyed by an electrical fire in 1969. The wrought-iron fence is still standing along University Avenue across from the engineering building.

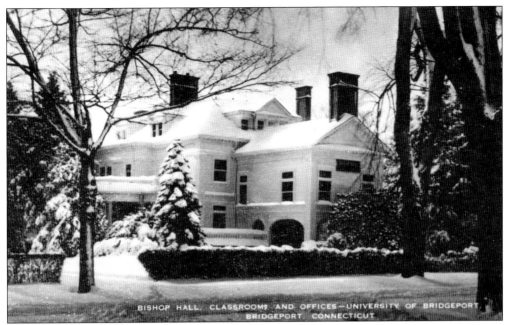

Bishop Hall was located at 301 Park Avenue on the southeast corner of Park Place, now known as University Avenue. It was built as the residence of Nathaniel W. Bishop in 1893. Acquired by the university in the 1940s for classroom space and offices, it was torn down in 1954 for the construction of the Carlson Library.

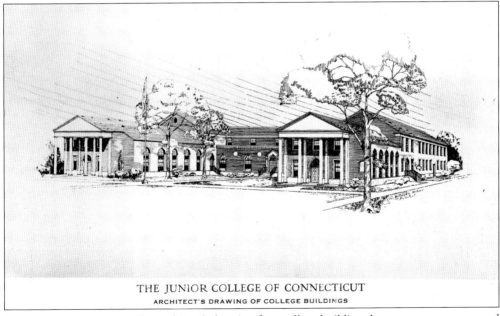

Shown here is a postcard of an architect's drawing for a college building that was never constructed for the Junior College of Connecticut. This building was meant to replace the four original mansions used by the college since 1927, including the Bassick mansion at 1001 Fairfield Avenue. After the college moved to Seaside Park, the property on the south side of Fairfield Avenue near Norman Street was sold, and the Campus Gardens apartments were built on the site.

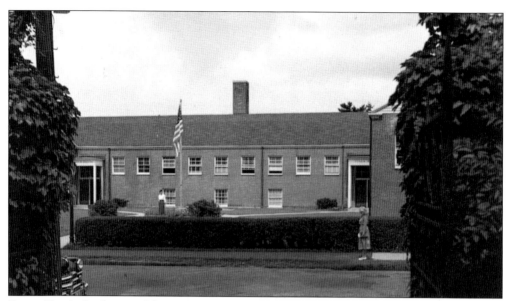

Framed by the back gate of the Marina Estate is Fones Memorial Hall on Park Place. Originally, this was a one-story wooden barracks building located at Camp Endicott, Rhode Island. The building was given to the university by the government and barged to the new campus in 1948. It was reconstructed as a two-story classroom building with brick fortified walls, becoming the first new building constructed on the new campus. It was torn down in 1979, and the Wheeler Recreation center was built on the site.

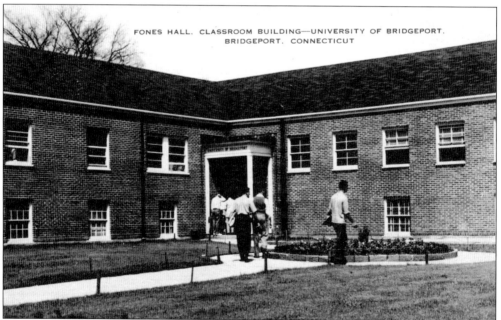

Dr. Alfred C. Fones, a pioneer in dental hygiene, was chairman of the board at the time the charter was granted to the Junior College of Connecticut in 1927. Fones Memorial Hall was built on the site of P. T. Barnum's private gardens, which extended from Park Place to Atlantic Street. The Fones School of Dental Hygiene and the Weylister School of Secretarial Studies were located here.

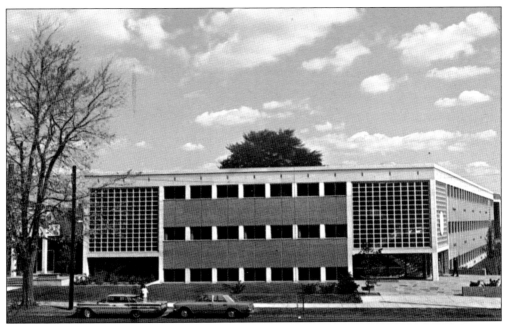

The College of Business Administration building, completed in the summer of 1964, was renamed Mandeville Hall later that year. It is located on the northeast corner of Park Avenue and University Avenue. This classroom building extends to Myrtle Avenue. The University of Bridgeport bookstore is located in this building at 225 Myrtle Avenue.

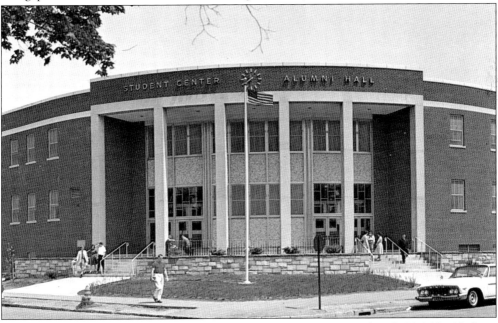

The Student Center/Alumni Hall building was built in 1962 with a $100,000 gift from philanthropist Charles A. Dana. It is located at the northeast corner of University Avenue and Myrtle Avenue. In the 1970s, this section of University Avenue from Park Avenue to Hazel Street was made into a pedestrian mall. In addition, a small part of Myrtle Avenue north and south of University Avenue is also for pedestrians only.

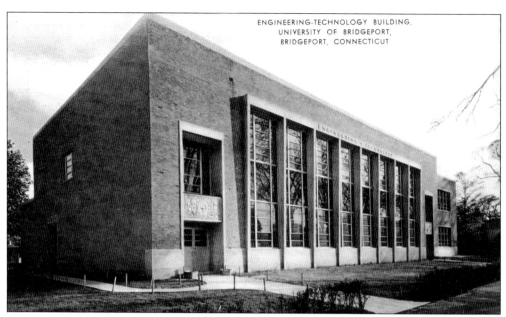

The engineering technology building is located on the southeast corner of University Avenue and Myrtle Avenue. This building provides facilities for engineering, physics, and chemistry, as well as classroom space for up to 600 students at one time. It was built in 1949 on the site of Dr. I. De Ver Warner's mansion. De Ver Warner willed that his mansion be torn down after his death.

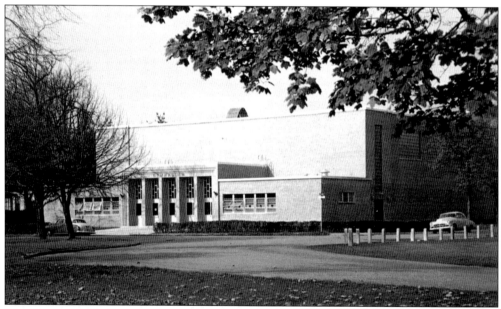

The Harvey Hubbell gymnasium is located on the northwest corner Waldemere Avenue and Hazel Street. This building, constructed in 1955 on the site of the original Waldemere Hall, is home to the University of Bridgeport men's and women's basketball teams and the women's volleyball team. In addition, many concerts were held here in the 1970s. The gymnasium is named after the Hubbell family in recognition of the generous support the family has given the university over the years.

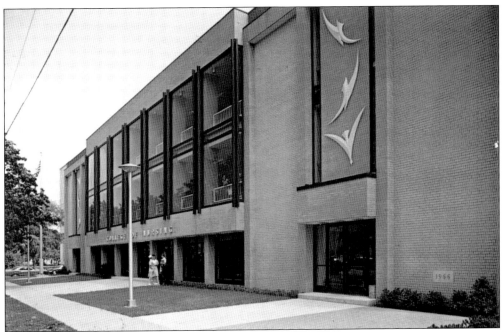

The College of Nursing building was constructed on the south side of Linden Avenue between Lafayette Street and Hazel Street. Charles A. Dana gave the university $300,000 for this building, which was completed in 1966. Today this is the home of the College of Chiropractic Medicine.

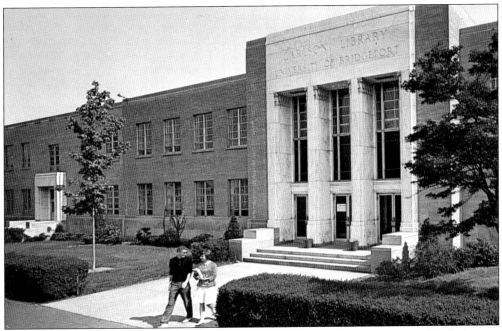

The Carlson Library, completed in 1956, is located on the southeast corner of Park Avenue and University Avenue. This building is named for Philip and William Carlson, founder of the Metropolitan Body Company of Bridgeport and longtime benefactors of the university. The main entrance to the 100,000-volume library is shown here on University Avenue.

Barnum Residence Hall was built in 1962 on the site of Seaside Hall. Overlooking Long Island Sound, this dormitory was the home of 200 coeds during the academic year. Named after P. T. Barnum, this building is in a scenic location on the southeast corner of Waldemere Avenue and Marina Park Circle.

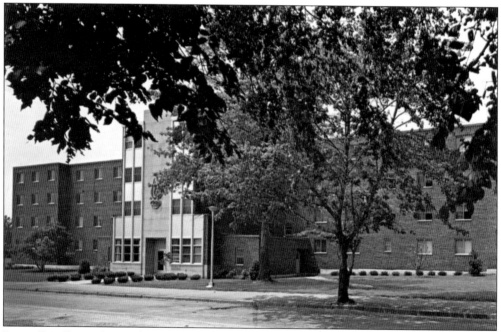

Rennell Hall-Bruel Hall is located on Iranistan Avenue between Atlantic Street and University Avenue. Named after two of Barnum's grandchildren, it was built in 1965 as a residence designed to house 497 men. This building is currently being renovated into the South End Elementary School, giving the city of Bridgeport much-needed classroom space.

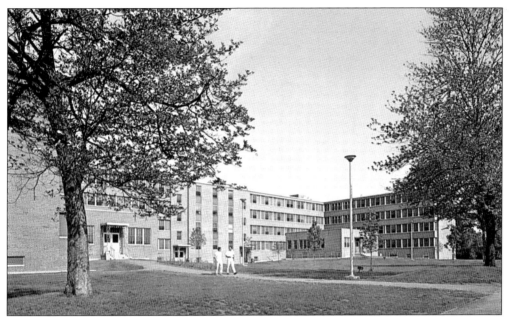

North and South men's residence hall was built in 1960 on Lafayette Street between University and Linden Avenues. The back of this building, which accommodates 436 students, is on Broad Street. A new soccer field has just been built directly in front of this dormitory, which closes off Lafayette Street. Hazel Street in front of the Charles A. Dana Hall of Science also has been closed for the new field.

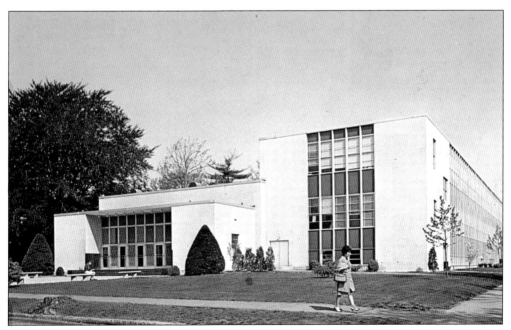

The Charles A. Dana Hall of Science opened in February 1960. Shown here is the entrance to Trustees Hall on the northwest corner of Linden Avenue and Hazel Street. The Charles A. Dana Hall of Science's Science Wall of Honor is at the opposite end of the building at Hazel Street on the corner of University Avenue.

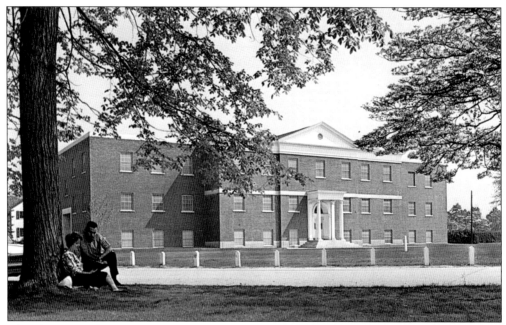

The Eleanor Naylor Dana (END) Hall was built in 1961 on Waldemere Avenue, between Hazel Street and Lafayette Street. Originally this was the home of the Junior College of Connecticut, which later became a division of the University of Bridgeport. Today this is the home of the School of Dental Hygiene and the Nutrition Institute.

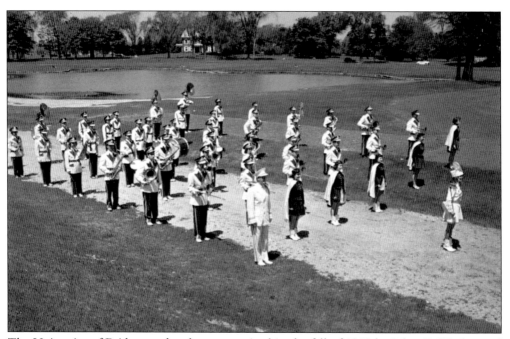

The University of Bridgeport band was organized in the fall of 1949 by John C. Worley, and by 1952, it numbered 60 members. The band has performed at varsity football games, campus activities, and in annual concerts held at the Klein Memorial Auditorium. The band is shown here practicing in beautiful Seaside Park on a perfect summer day.

Two

ALONG MAIN STREET

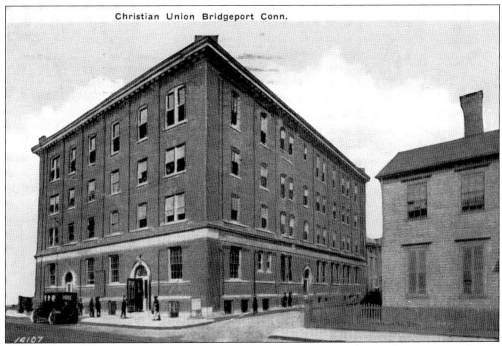

Christian Union Bridgeport Conn.

The Christian Union Church building was constructed in 1919 on the northeast corner of Main Street and Thomas Street, one block south of Gilbert Street. Located at 786 Main Street, this building also contained a dormitory with a kitchen. It was demolished in 1956 for the construction of the Connecticut Turnpike. Thomas Street was also abandoned for the highway.

Shown here is a postcard view of Main Street looking north from about 1920. The distinctive Barnum Institute of Science and History building can be seen on the right at the corner of Gilbert Street. Also on the right is a double house built in the 1840s in the Greek Revival style. On the left is the YMCA building with a flagpole on the tower. In the distance is the First National Bank building.

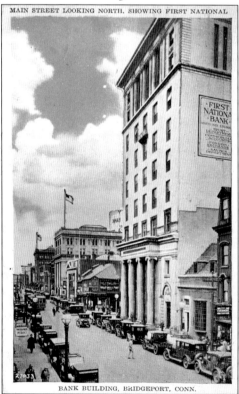

MAIN STREET LOOKING NORTH, SHOWING FIRST NATIONAL

BANK BUILDING, BRIDGEPORT, CONN.

The First National Bank building was constructed in 1915 on the southeast corner of Main Street and State Street. Between 1972 and 1974, a 10-story addition was constructed alongside it on State Street. On April 20, 1986, the whole structure was imploded using 170 pounds of dynamite. Bridgeport Center occupies the site today.

The Bridgeport Savings Bank was constructed in 1917 on the southwest corner of Main Street and State Street. This bank merged with Peoples Savings Bank around 1929. The architect was Cass Gilbert, who also designed the U.S. Supreme Court building in Washington, D.C. The two distinctive bronze doors were on display at Tiffany and Company in New York prior to their installation on this building. Roberto's Restaurant has occupied this beautiful building since 1994.

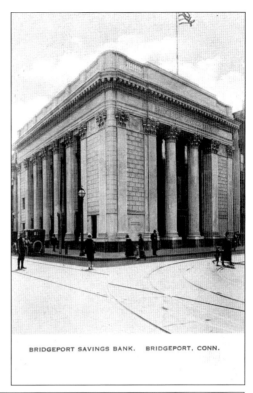

BRIDGEPORT SAVINGS BANK. BRIDGEPORT, CONN.

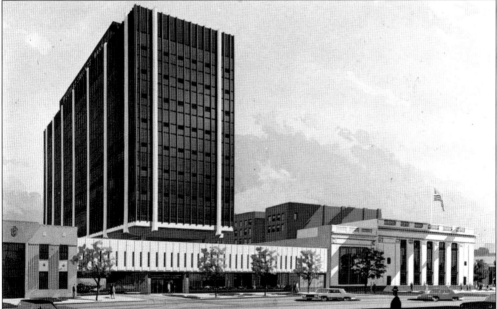

Shown here is a postcard of the original architect's drawing for the new Peoples Savings Bank tower built in 1966. The new headquarters was built on the site of the Park Theater, which was originally Barnum's Recreation Hall. On the left on the corner of Gilbert Street is the Bridgeport Hydraulic Company building, and on the right, the original Peoples Savings Bank building can be seen on the corner of State Street.

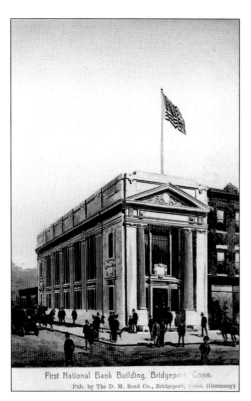

First National Bank Building, Bridgeport, Conn.
Pub. by The D. M. Read Co., Bridgeport, Conn. (Germany)

The First National Bank building was constructed in 1905 on the southeast corner of Main Street and Bank Street. This is a rare view since Peoples Savings Bank constructed a similar building right next door in 1907. Mechanics and Farmers Bank unified the facade in 1930 when it built its headquarters here. The original north facade facing Bank Street remains unchanged to this day.

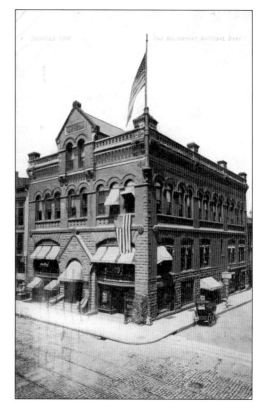

The United Bank building was constructed in 1885 on the northeast corner of Main Street and Bank Street. This highly decorative building was shared by the Bridgeport National Bank and the City Savings Bank. This postcard was mailed on May 15, 1908. Bridgeport National Bank, advertised as the oldest bank in Bridgeport, was founded in 1806. It was torn down in 1912 when the City Savings Bank building was constructed on this site.

The Liberty building was constructed in 1918 on the northwest corner of Main Street and Bank Street. The name reflects the patriotism evident at the time of its construction during World War I. Bridgeport was in the midst of a building boom during this period of its history. This office building is currently being renovated into apartments and retail space.

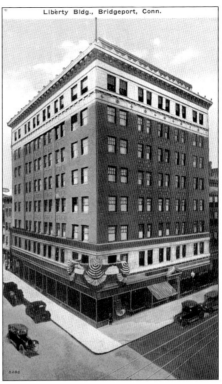
Liberty Bldg., Bridgeport, Conn.

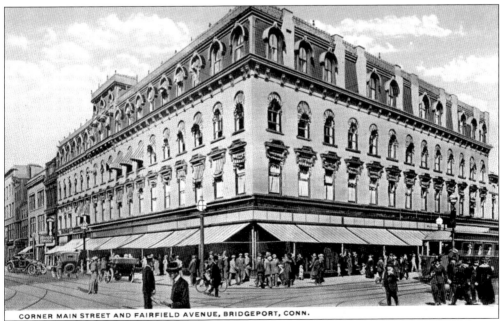
CORNER MAIN STREET AND FAIRFIELD AVENUE, BRIDGEPORT, CONN.

Shown here is a postcard view of the busy corner—Main Street and Fairfield Avenue in downtown Bridgeport. On the northwest corner is the D.M. Read's Department Store building originally constructed in 1869 and expanded over the years. Many shoppers line the sidewalks, and a streetcar is getting ready to pick some of them up as well as drop some more off. Read's moved to its new store on Broad Street in 1926.

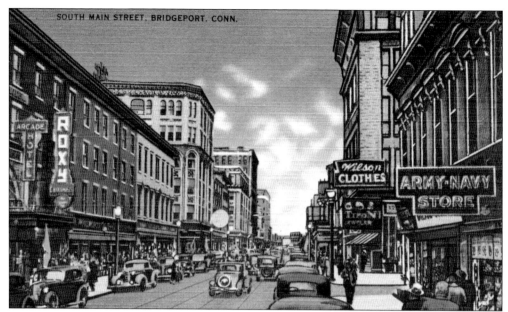

Main Street in the 1940s is shown in this postcard view looking north. The Arcade Hotel is on the left with many storefronts, including Roxy Clothes and Woolworth's. The Howland's Department Store occupies the Sanford building, also seen on the left. The building on the right was built in the 1800s, and interestingly, an Army-Navy store still occupies this site today but in a newer building.

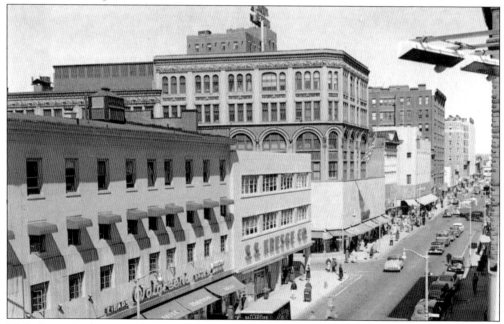

Main Street in the 1950s shows some changes, including the absence of the trolley tracks. The Walgreen's store now occupies the Arcade Hotel storefront with S. S. Kresge on the corner. Howland's still occupies the Sanford building, which was constructed in 1891 on the northwest corner of Cannon Street. In the late 1960s, this building was demolished for the construction of the Fairfield County Courthouse.

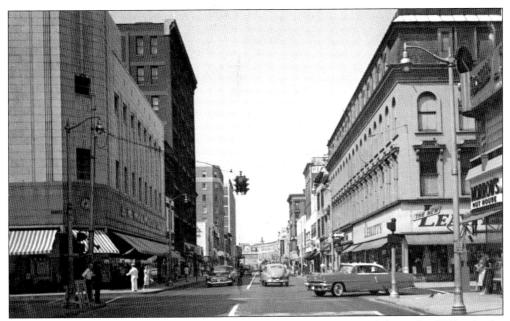

Another view of Main Street looking north is shown in this postcard from the 1950s. At the intersection of Fairfield Avenue, Leavett's Department Store occupies the Read's building, which is now painted dark gray. Woolworth's occupies the art deco–style building on the northwest corner. This building was completed in 1947. Its construction was often delayed because of the wartime shortage of building materials

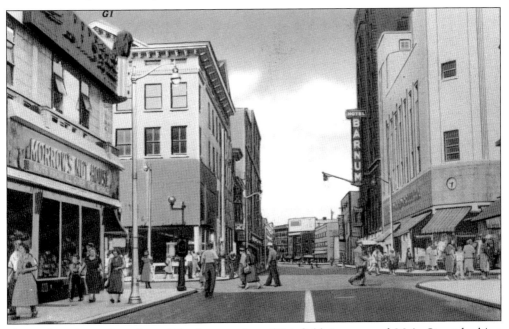

Shown here is another view of the intersection of Fairfield Avenue and Main Street looking west down Fairfield Avenue. On the left is Morrow's Nut House, which was very popular at the time. Morrow's was located on the southeast corner. In the 1940s and 1950s, all the stores downtown stayed open late every Thursday night.

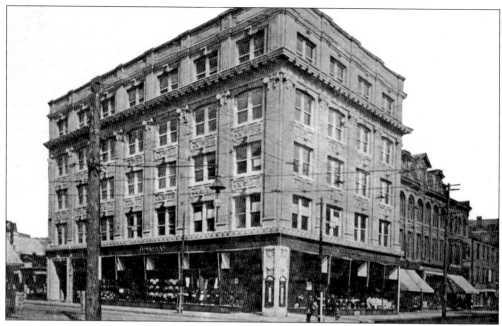

Meigs Department Store was founded in 1888 and constructed this building in 1897 on the northwest corner of Main Street and Fairfield Avenue. Note the absence of the Barnum Hotel later built on the left and the Security building later constructed on the right. The Meigs building was torn down in the 1940s.

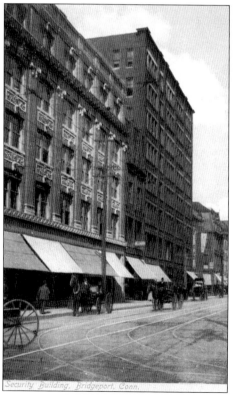

The eight-story Security building, shown in this early postcard view, was constructed in 1905. This building, along with the Stratfield Hotel and others along Main Street, was constructed by the heirs of Nathaniel Wheeler. This building, with its beautiful central atrium, is still standing at 1115 Main Street. On the left is the nicely detailed Meigs building on the corner of Fairfield Avenue.

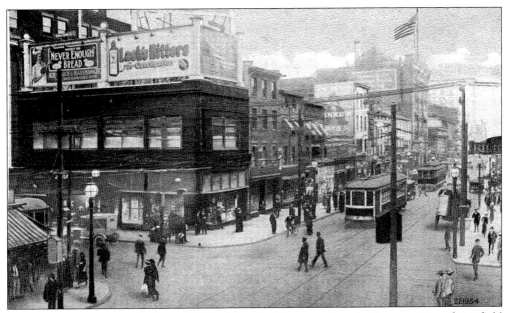

Shown here is a postcard view of Main Street looking south at the intersection of Fairfield Avenue. This 1920s scene shows a lot of activity with two streetcars on Main Street and another one on Fairfield Avenue. Note the billboards advertising Lash's Bitters and Plassmann's Bakery. The entire block shown on the left was torn down in 1979, and a hotel was eventually built on the site, now the Holiday Inn.

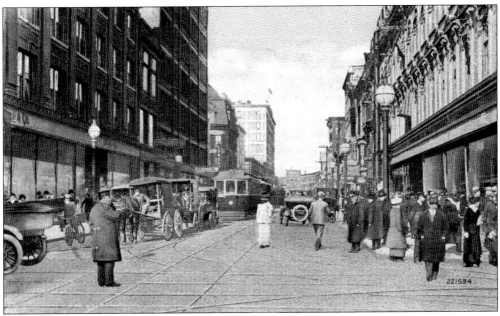

A very busy scene of Main Street looking north just past the intersection of Fairfield Avenue is featured on this early postcard. The Meigs Department Store is on the left and the D. M. Read's Department Store is on the right. Shown are bicycles, early automobiles, streetcars, horse and buggies, and pedestrians spilling out into the street. A policeman is captured blowing his whistle at the time the photograph was taken.

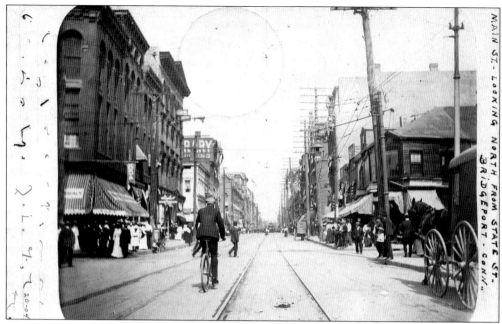

This early view of Main Street looking north at the intersection of State Street was postmarked in 1904. The brick buildings on the left between State Street and Bank Street were demolished in 1959 for much-needed parking downtown. After a few years, the small parking lot was added to McLevy Green.

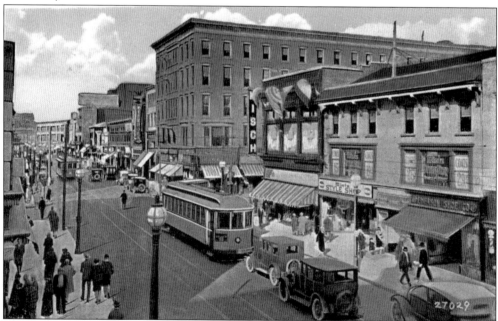

This postcard shows a slightly elevated view of Main Street looking north from Elm Street. The large brick edifice on the right is the Elijah Hubbell building constructed in 1871 in the Italianate style on the northeast corner of Golden Hill Street. The building on the southeast corner was built in 1905, and in the 1920s, it was the location for Caesar Misch's clothing store. This building was remodeled and enlarged in the 1950s for Kay's Department Store.

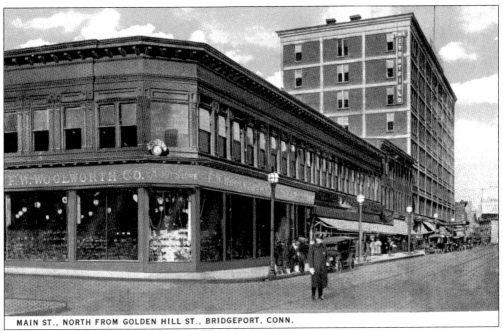

MAIN ST., NORTH FROM GOLDEN HILL ST., BRIDGEPORT, CONN.

This postcard from about 1920 shows Main Street looking north at the intersection of Golden Hill Street. The building on the northwest corner dates to the 1890s and was occupied by the F. W. Woolworth five-and-dime store. This building was torn down and replaced by the Wheeler building in 1924. The Stratfield Hotel can be seen further up Main Street.

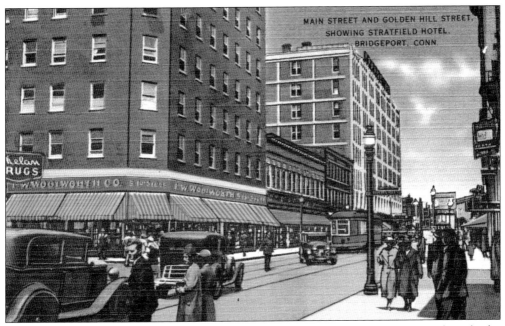

This postcard from about 1930 shows the same intersection with Golden Hill Street. The Wheeler building now occupies the site and the Woolworth's store managed to keep the same location. Note that a portion of the original structure is still standing between the Wheeler building and the Stratfield Hotel.

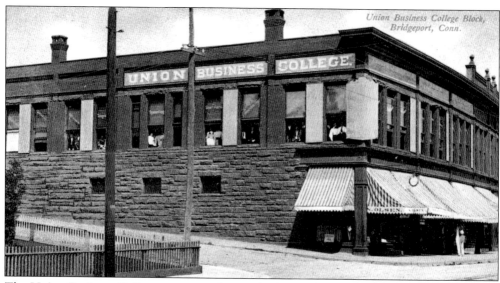

The Union Business College was one of many business schools located in Bridgeport in the early 1900s. The Nichols–Sterling building shown in this view was constructed in 1893 on the west side of Main Street between Chapel Street and Congress Street. Curving with Main Street, this beautiful stone building required a lot of craftsmanship to construct. It was torn down in 1977 after preservationists lost a battle to save it. Note that this photograph was taken before the Stratfield Hotel was built. The hotel was constructed a few years later where the fence is on the left.

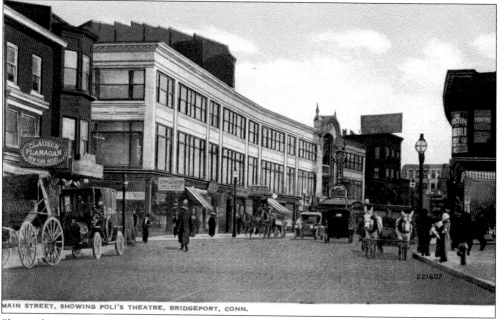

MAIN STREET, SHOWING POLI'S THEATRE, BRIDGEPORT, CONN.

Shown here is a postcard view of Main Street looking south at the intersection with Congress Street. Highlighted is the Poli Theater building constructed in 1912 and renamed the Globe when Poli's Palace and Majestic Theaters opened in 1922. The height of the interior of the theater is evident by the section of the building above the facade. The back of the stage was located along Congress Street. This building was torn down in 1957 for a parking lot.

Three

TRANSPORTATION
RELATED

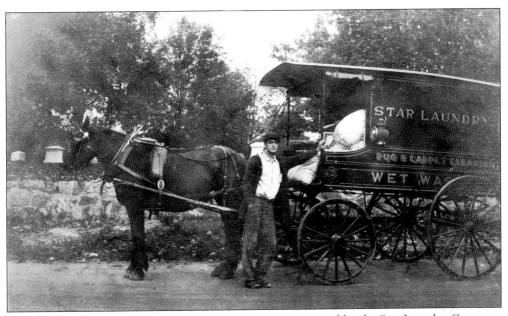

A driver proudly poses with a horse and delivery wagon owned by the Star Laundry Company of 1019 Broad Street. Even with the advent of the automobile, many business owners preferred the use of horse and wagons to make their deliveries. Eventually the horseless carriage took over, leading to the decline in the businesses that supported these horse and buggies for many years.

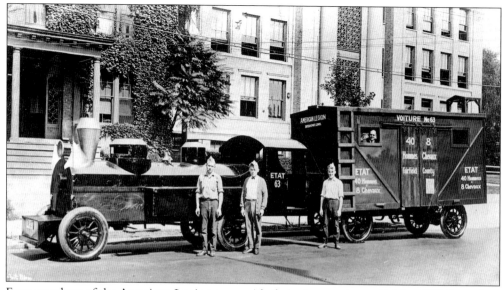

Four members of the American Legion pose with their street train on Golden Hill Street in a Lew Corbit photograph dated September 13, 1928. Written on the side of the car is *voiture etat,* French for railway coach. The building on the right is the Bridgeport Central High School, now city hall. The apartment house on the left predates the high school. The land was not acquired by the city at the time the school was constructed, so the school was built around it. The apartment house was torn down in 1960 for the same reason the Wheeler Mansion next door was destroyed.

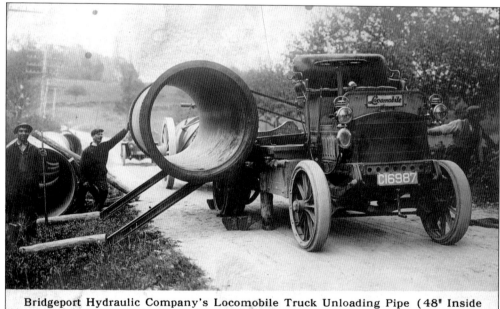

Bridgeport Hydraulic Company's Locomobile Truck Unloading Pipe (48" Inside Diameter, 5 Tons to the Piece) in Construction of 4,500,000,000 Gallon Reservoir

This rare real–photo postcard shows the construction of the Hemlocks Reservoir in Fairfield by the Bridgeport Hydraulic Company, now Aquarion. Work on the reservoir was started in late 1912 and was completed in 1914. Workers are shown unloading pipes weighing five tons apiece from a specially equipped Locomobile truck. In 2007, Aquarion celebrated its 150th anniversary.

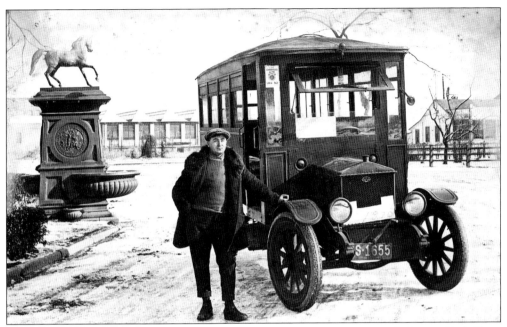

A driver employed by the White Lines Bus Company poses next to an early bus on Park Place across from Seaside Park around 1920. The Bergh fountain can be seen on the left with Main Street in the background. Note the Teamsters Local Union sticker affixed to the windshield.

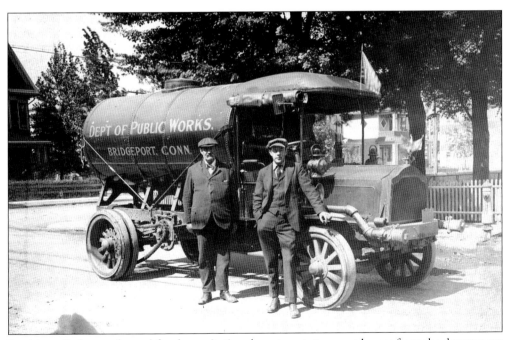

Looking a little overdressed for the sanitation department, two employees from the department of public works pose with their versatile-looking truck around 1917. The man on the right is the driver of the truck in a similar photograph by Lew Corbit that also features both men.

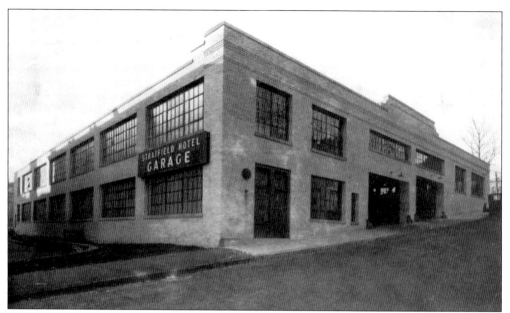

In this postcard from 1929, the sender apologized for the subject matter, explaining that this card was all he could find. This is a rare view of the Stratfield Hotel garage located on 95 Chapel Street. The Stratfield was the largest hotel in Bridgeport and eventually took over the entire south side of Chapel Street as it expanded. Today this garage is still in use and owned by the State of Connecticut.

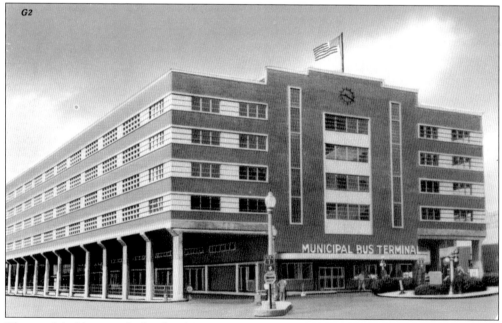

The municipal bus terminal and parking garage was built in 1951 on the site of the Plaza bounded by Water Street, John Street, Middle Street, and State Street. Located inside the building was a waiting room with lockers, snack machines, restrooms, and an escalator to the parking levels above. With the construction of the new bus terminal early in 2008, this building is now used exclusively as a parking garage with room for 520 cars.

The Blue Ribbon Garage is shown here in its fireproof building constructed in 1908 at 277 Fairfield Avenue. Inside this handsome building were showrooms and large elevators to move the cars between the floors. The Bijou Theater was built a year later to the left of the Blue Ribbon Garage. Both of these fine buildings have recently undergone restoration by Phil Kuchma. Today, Two Boots Restaurant occupies the first floor of the Blue Ribbon Garage building.

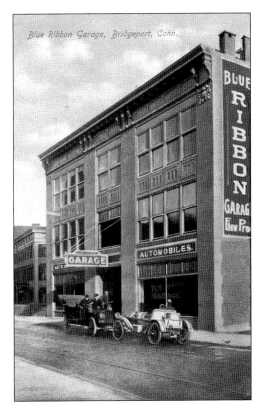

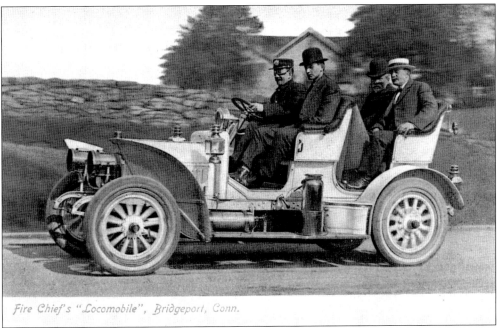

Fire Chief Edward Mooney takes his three passengers out for a ride in the country in the fire department's Bridgeport-made Locomobile car around 1910. Note the pontoon fenders and right-hand drive. Where is this beautiful vehicle today?

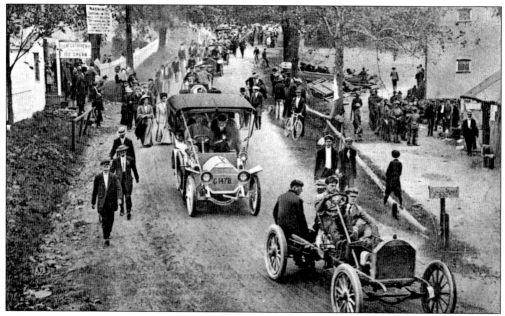

The Bridgeport Automobile Club sponsored an annual car race up Sport Hill Road in Easton on Memorial Day. The hill climb began at the Mill River at the bottom of the hill and ended at Flat Rock Road near the Jesse Lee United Methodist Church. This section of Route 59 in Easton has officially been called Sport Hill Road since World War II. In this postcard view, J. J. Coffey, driving a Columbia car, is seen coming down the hill after the 1908 race.

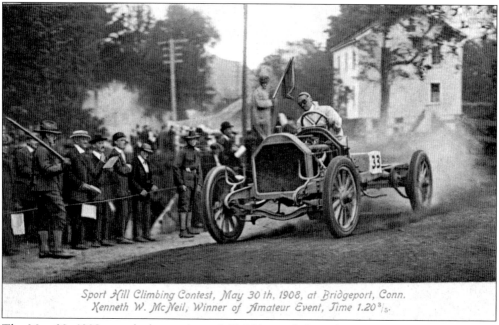

Sport Hill Climbing Contest, May 30th, 1908, at Bridgeport, Conn. Kenneth W. McNeil, Winner of Amateur Event, Time 1.20 3/5.

The May 30, 1908, race had an estimated 10,000 people line the route to watch the contest. Forty troops from the state militia kept order during the event. This was a timed race; drivers raced against a clock rather than each other. The fastest cars with the most skilled drivers made it up the half-mile hill in about 90 seconds.

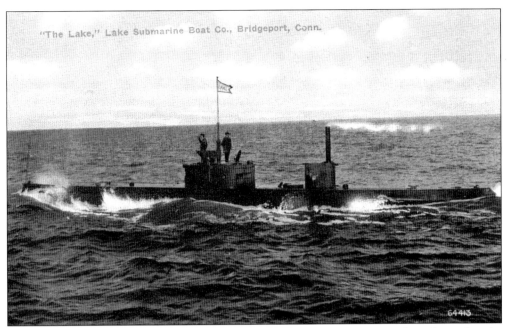

"The Lake," Lake Submarine Boat Co., Bridgeport, Conn.

The Lake Torpedo Boat Company was founded by Simon Lake in 1912 and was located at the foot of Seaview Avenue. A total of 24 submarines were built for the U.S. Navy during and after World War I. The company's wartime motto was "No slacker at the Lake." The company was closed by financial difficulties around 1925.

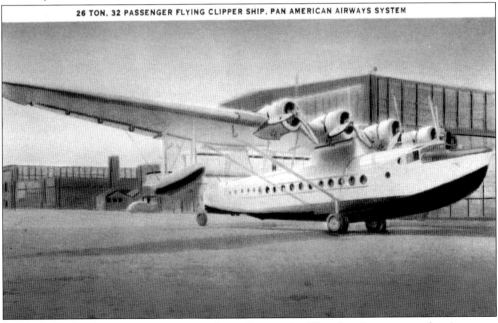

26 TON, 32 PASSENGER FLYING CLIPPER SHIP, PAN AMERICAN AIRWAYS SYSTEM

This postcard shows the Sikorsky S-42 Flying Boat at the Sikorsky plant next to the airport on Main Street in Stratford. Introduced in 1934 for Pan American Airways, the aircraft boasted a wingspan of 118 feet with four Pratt and Whitney 700-horsepower radial engines. The Flying Clipper Ship could carry 32 passengers and a crew of four 2,500 miles nonstop. Only 10 were built, and none exist today.

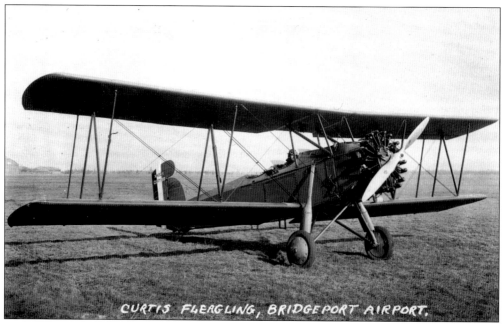

CURTIS FLEDGLING, BRIDGEPORT AIRPORT.

The Curtis Fledgling was an early aircraft considered one of the finest training planes ever made. Built by the Curtis Aeroplane and Motor Company of Buffalo, New York, the Fledgling made its maiden flight in 1927. This was a conventional biplane with staggered wings braced with N struts. The pilot and instructor sat in tandem, open cockpits.

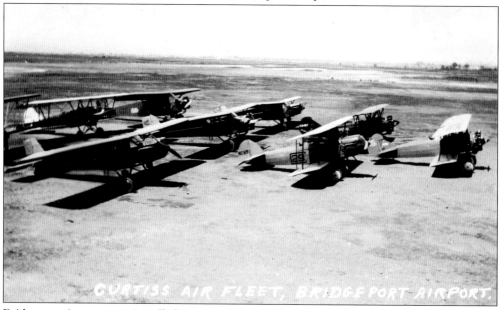

CURTISS AIR FLEET, BRIDGEPORT AIRPORT.

Bridgeport airport was originally known as Avon Field—a racetrack with aviators landing on the grass infield. In 1933, a crash landing occurred here when Capt. James Mollison was attempting to fly across the Atlantic Ocean from Wales to New York. After this incident, the name was changed to Mollison Field. In 1937, the name was again changed to Bridgeport Municipal Airport when the city purchased the airfield. In 1972, it was rededicated as the Igor I. Sikorsky Memorial Airport after the death of the aviation pioneer.

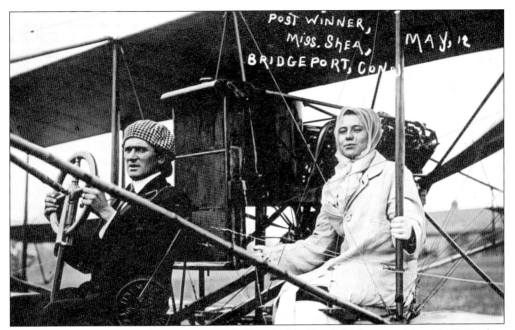

Lincoln Beachey poses with Marguerite M. Shea in his Curtis biplane on May 12, 1911. Shea won a free airplane ride in a contest sponsored by the *Bridgeport Post* newspaper. Her heroic ride took place during the Bridgeport aviation meet held at Aerodrome Park in Stratford sponsored by the Aero Club of Connecticut and the Bridgeport Board of Trade.

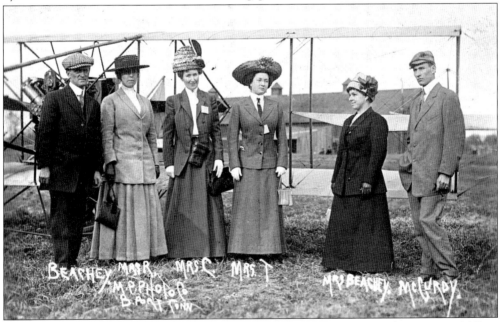

World-famous aviation pioneer Lincoln Beachey poses with his wife, several women, and fellow aviator J. A. D. McCurdy in front of his Curtis biplane at Aerodrome Park in Stratford on May 11, 1911. Beachey had just become the first aviator to fly a heavier-than-air machine over Bridgeport by flying from Stratford over the east side of the city to the Stratfield Hotel, which he circled before flying back to Aerodrome Park.

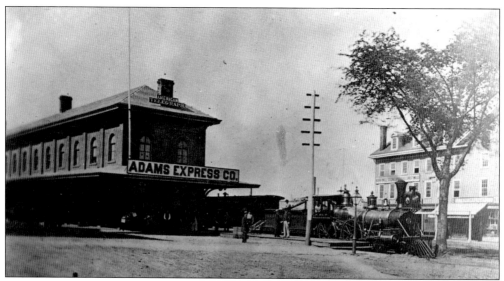

This real-photo postcard from 1910 of the Bridgeport train depot was made from a stereo view image from 1868. Originally built in the 1860s as a terminal for the Housatonic Railroad, it later became the Bridgeport station along the New York, New Haven and Hartford Railroad as well. This photograph was taken from the southwest corner of Fairfield Avenue and Water Street looking northeast. The building on the right was occupied by Calhoun's Saddle factory during the Civil War. Bridgeport harbor is hidden behind it. Note the telegraph pole to the right of the station.

Adams Express was founded by Alvin Adams in 1840 as an early package delivery service but was not allowed to compete with the U.S. Postal Service and deliver mail. After sharing its first quarters with the railroad depot, it now occupies its own building adjacent to the new train station. Both buildings were constructed in 1905 of the same style using the same materials. The caption on the back of the card states that the photograph was taken just after the building was finished. Adams Express still exists today as an investment banking firm.

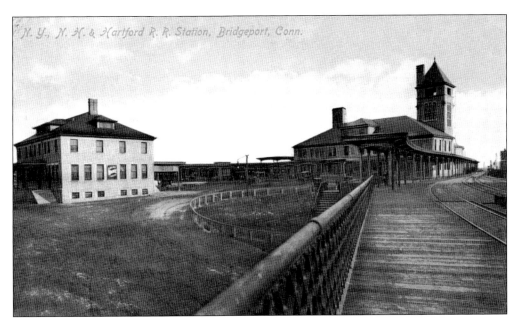

Shown here is a view of the new train station and Adams Express building from about 1908. No disruption in train service occurred while the new train station was being constructed at the same time the tracks were being elevated. The Adams Express building was torn down in the 1960s to create more parking for the train station. In 1979, the Romanesque station building was destroyed by arson.

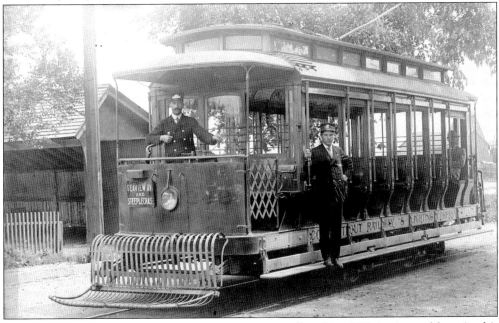

The Connecticut Railway and Lighting Company trolley (No. 242) is pictured here in this photograph from about 1910. Early trolleys were horse drawn, but later ones such as this were supplied with power from overhead electric wires. The destination of this trolley was Seaview Avenue and Steeplechase Island. The motorman is at the front, a conductor is on the right, and a lone passenger is in the back.

The side-wheel steamer *Bridgeport* was built in Wilmington, Delaware, in 1902 as the *William G. Payne* for the Bridgeport Steamboat Company. The steamer was renamed *Bridgeport* in 1903 after the Bridgeport Steamboat Company was acquired by the New York, New Haven and Hartford Railroad. The steamer *Bridgeport* operated between Bridgeport and Manhattan until 1914 and was one of the last as well as the fastest steamers.

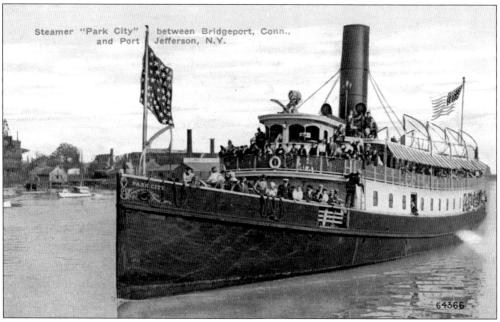

The *Park City* was launched on March 15, 1898, from Port Jefferson, Long Island. This boat was built for the Bridgeport and Port Jefferson Steamboat Company. It was constructed by the Mather and Wood Company at a cost of $50,000. In 1921, the *Park City* was modified to carry more automobiles with a turnstile added to make loading and unloading cars easier. In 1949, the *Park City* was retired from service and sank while being towed in 1951 off the New Jersey coast.

Four

ON THE WATERFRONT

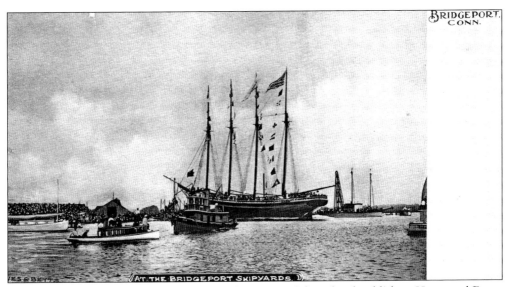

At the Bridgeport Shipyards is the title of this postcard from local publishers Hayes and Betts. This shipyard specialized in the construction of schooners with multiple masts. Shipbuilding has always been a part of Bridgeport's history, and Derecktor Shipyards continues this tradition today.

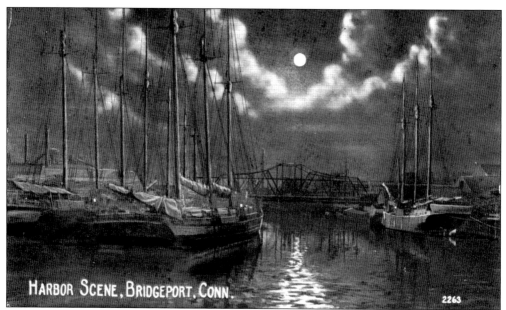

HARBOR SCENE, BRIDGEPORT, CONN.

2263

This postcard view shows a moonlit harbor scene with many boats sitting idle overnight waiting to be put out to sea the following day. Seen in the center of the picture is an earlier version of the East Washington Avenue bridge. Barely visible through the bridge is the power plant of the United Illuminating Company that was located on Congress Street next to the present headquarters of the Bridgeport Fire Department.

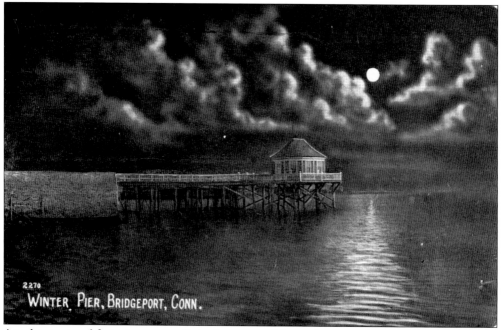

2270

WINTER PIER, BRIDGEPORT, CONN.

Another postcard featuring a moonlit harbor scene, this one is postmarked August 1912. Winter Pier was initially built by the Naugatuck Railroad Company and was located at the foot of South Avenue on what is now the property of the United Illuminating Company. This pier, added to later by an owner named Winter, was used mainly for pleasure craft in later years.

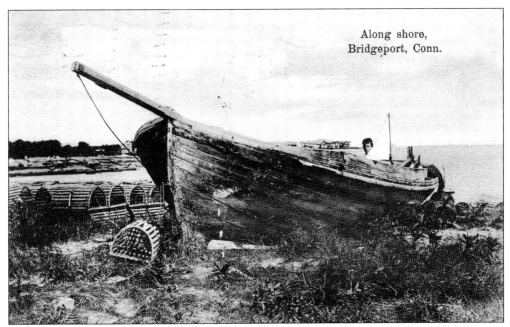

Rows of lobster pots were one of the items one was sure to find along the shore in Bridgeport when this postcard was sent to South Meriden in 1912. The publisher of the postcard was G. E. Southworth, whose stationery store was located in the Arcade Shopping Center.

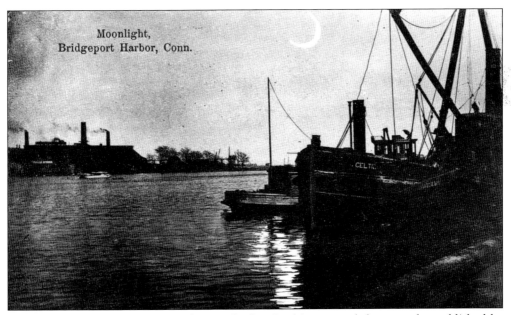

A crescent moon shines over Bridgeport harbor in this postcard that was also published by Southworth. This view looks southeast from the western end of the Stratford Avenue bridge. The smokestacks on the building on the left belong to the Farist Steel Company. Today this land is still known as Steel Point, named after this steel mill. The United Illuminating Company had a generating plant here for many years until it was imploded for the Harbor Point redevelopment project.

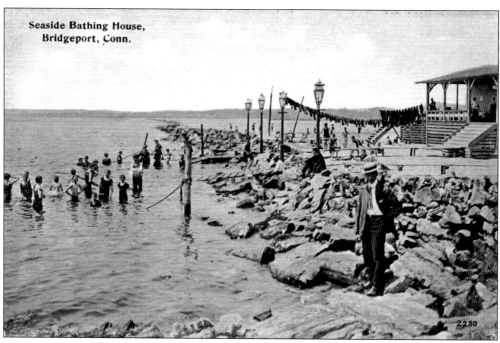

Seaside Bathing House,
Bridgeport, Conn.

A very rocky beach is evident in front of the original bathhouse that dates back to the 1880s at Seaside Park. This view is looking west toward Black Rock. Note the gaslights to illuminate the area at night. This same beach today is covered by sand and is no longer strewn with rocks.

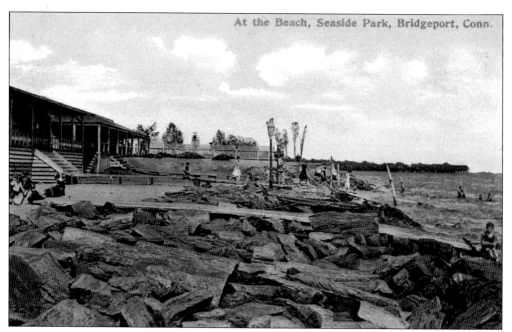

At the Beach, Seaside Park, Bridgeport, Conn.

Here is another postcard view of the old bathhouse at Seaside Park, looking east. This original bathhouse was located directly on the water and was replaced by a new bathhouse built across the street in 1916. Note the use of planks to get across the rocks and into the water.

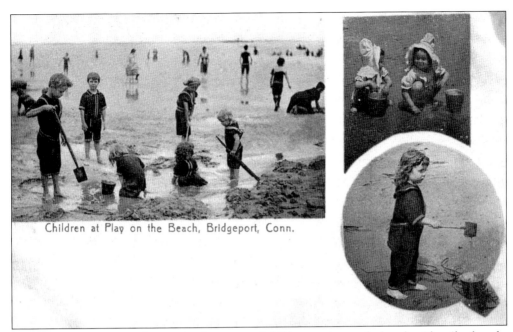

Children at Play on the Beach, Bridgeport, Conn.

This postcard from 1908 shows a timeless scene of children at play on the beach with pails, shovels, and plenty of sand. Children of all ages flocked to the beach during the summer months, and residents had Seaside Park or Steeplechase Island/Pleasure Beach to choose from.

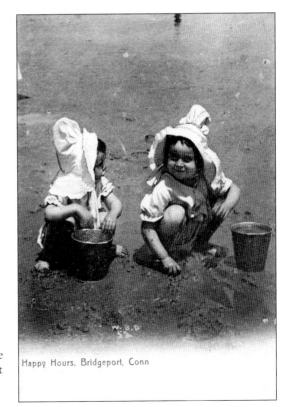

Happy Hours, Bridgeport, Conn

A close-up of the two girls playing on the beach in their cute bonnets is taken from the multiple view postcard from above. The children are properly dressed to keep them protected from the sun. The postcard portrays many happy hours spent on the beach and memories that will last a lifetime.

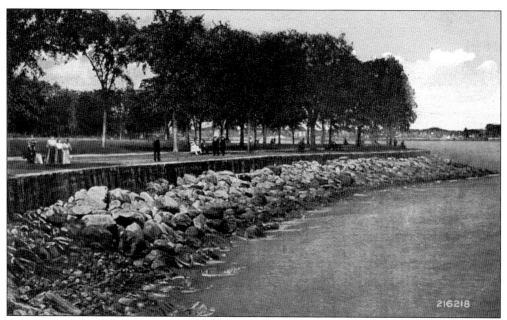

A promenade built along the seawall was just one of many features that made Seaside Park one of the greatest municipal parks on the eastern seaboard. The promenade or walkway along the water became popular in Victorian times and made it fashionable to visit seaside resorts. A level walkway allows for a pleasant stroll along the water without having to worry about the tides or being injured while walking on a rocky beach.

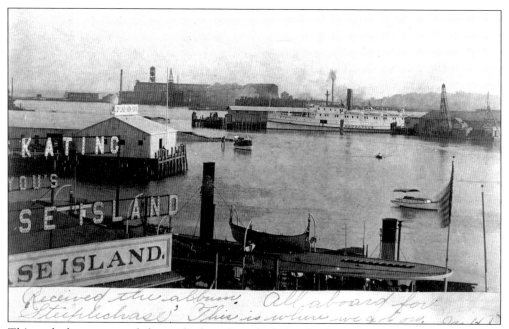

This real-photo postcard shows the boarding dock for the ferry to Steeplechase Island. The photograph was taken from the eastern end of the Stratford Avenue bridge and looks southwest across the harbor. The building in the distance is the Locomobile factory, and the large boat at the dock is the steamer *Naugatuck*. This postcard was sent to Scranton, Pennsylvania, in 1906.

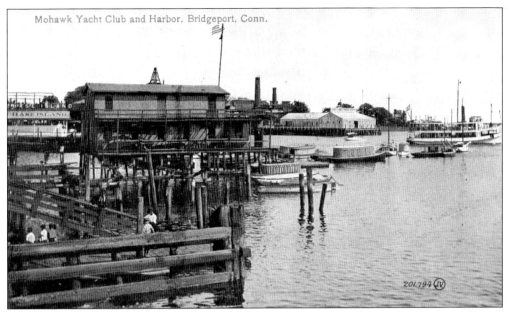

The Mohawk Yacht Club was organized in 1903 and was strictly for powered boats, although a few sailboats were allowed into the fleet. The two-story wooden building on pilings was originally used by boat builder George W. Masters and became the home of the new yacht club. The photograph was taken just south of the Stratford Avenue bridge. On the left can be seen part of the protective barrier around the bridge supports.

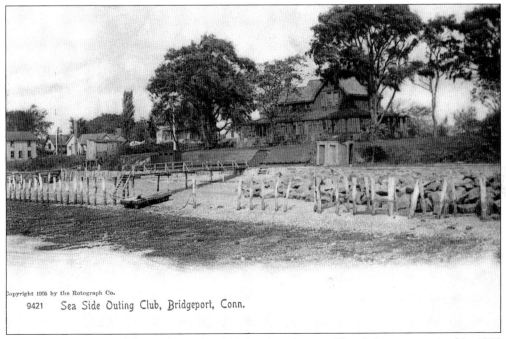

9421 Sea Side Outing Club, Bridgeport, Conn.

The Seaside Outing Club was located at 215 Seaview Avenue The club was organized in 1895 and had disbanded by 1920. Many clambakes must have been held here along the water. The site is now a vacant lot in an industrial area near the Pleasure Beach bridge.

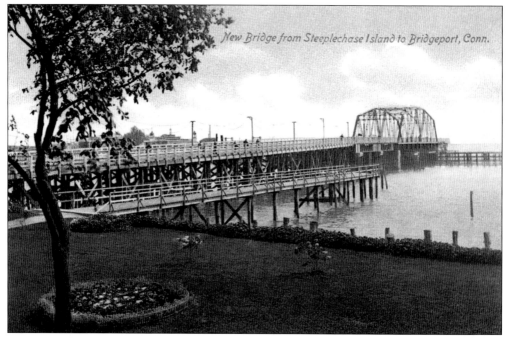

A beautiful setting on Seaview Avenue is evident along the water next to the new bridge from Steeplechase Island. The tops of some of the amusement buildings on the island are visible above the bridge on the left. This vital link to the island burned in 1996, forcing the abandonment of the cottages on the Stratford side as well as the parkland on the Bridgeport side.

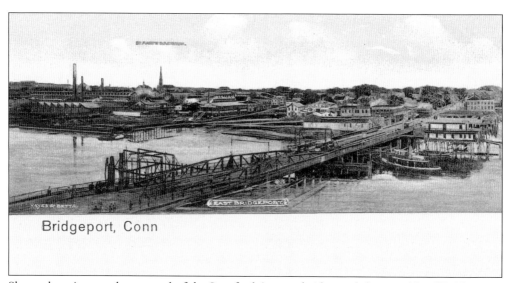

Shown here is an early postcard of the Stratford Avenue bridge and the east side of Bridgeport. When this span across the Pequonnock River was completed in 1888, P. T. Barnum demonstrated the strength of the new bridge by taking 12 of his circus elephants onto it. This structure was replaced by another bridge in 1912.

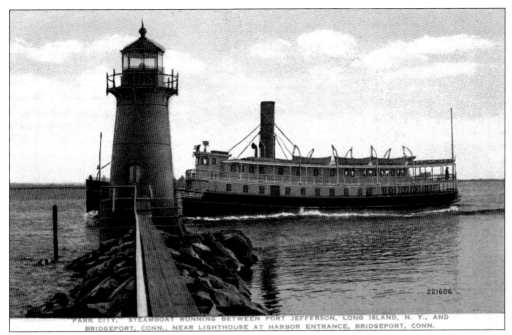

The *Park City* passes the inner harbor light on its way into Bridgeport harbor from Port Jefferson, Long Island. This cast-iron lighthouse was built in 1895 and is also known as the Tongue Point Light and the Bug Light. The lighthouse was built at the end of a breakwater that ran east to west.

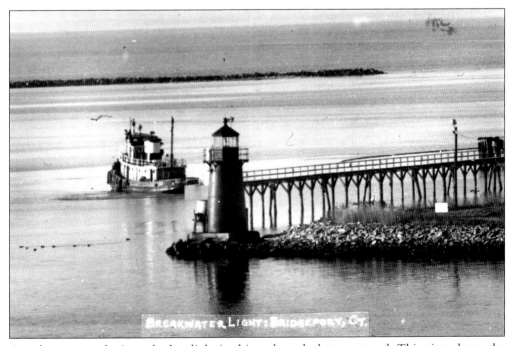

A tugboat passes the inner harbor light in this early real-photo postcard. This view shows the lighthouse after 1921 when the area around this breakwater was filled in. In 1954, this light was automated and is still active today.

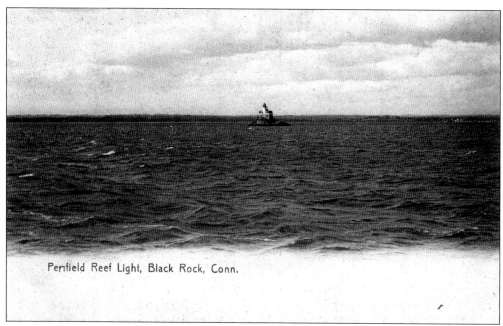

Penfield Reef Light, Black Rock, Conn.

A distant view of the Penfield Reef Lighthouse is shown in this postcard from around 1905. This lighthouse was built in 1874 and is named after a colonial resident of Fairfield. A mansard roof and Second Empire details made it appear very similar to the Bridgeport harbor light built at the same time.

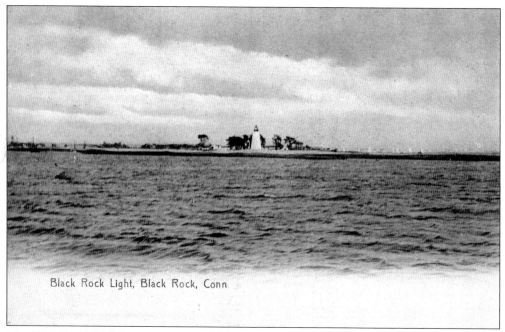

Black Rock Light, Black Rock, Conn.

The Black Rock Lighthouse was originally built in 1809 and was rebuilt in 1823. The lighthouse is located on Fayerweather Island, which has been attached to Seaside Park by a breakwater since 1917. This breakwater was started in 1837 to protect the island from erosion. Black Rock light was decommissioned in 1932 and replaced by a beacon a quarter mile offshore in 1933.

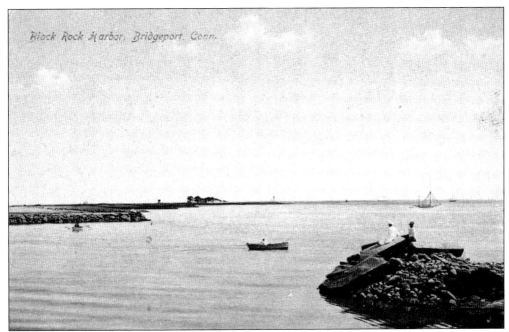

This postcard view of Black Rock Harbor shows how calm and peaceful this well-protected harbor can be. In the distance, Fayerweather Island and the Black Rock Lighthouse can be seen. On the left is one of three breakwaters that used to jut out from the western side of Seaside Park. Today the Port Five Yacht Club is located just beyond those rocks on the right side of the picture.

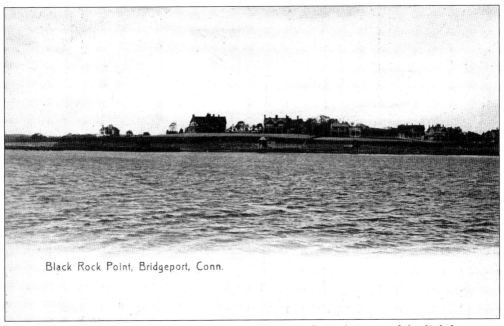

This is how Black Rock looked a century ago as seen from the area of the lighthouse on Fayerweather Island. The large mansions seen here were located on Grovers Avenue when this road ended at the point on the left. In the 1930s, Eames Boulevard was built, which connected with Grovers Avenue.

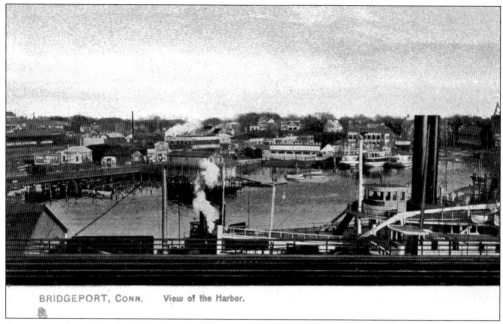

BRIDGEPORT, CONN. View of the Harbor.

A postcard from Raphael Tuck and Sons illustrates a view of the harbor looking towards the east. These Tuck postcards all came with a detailed explanation on the back. A part of the Stratford Avenue bridge from 1888 is at left, and the dock for the Steeplechase Island ferry is in the distance.

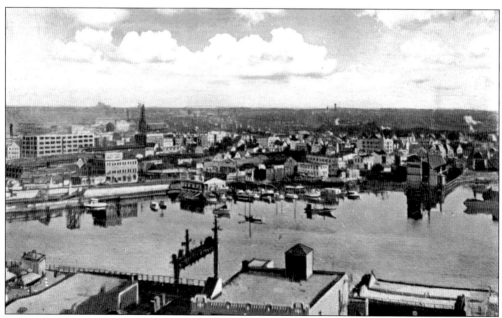

The factories on the eastern side of Bridgeport can be seen in this postcard view also looking east. On the left is the Stratford Avenue bridge built in 1912. In the foreground are buildings once located on Water Street, and beyond them are the railroad tracks.

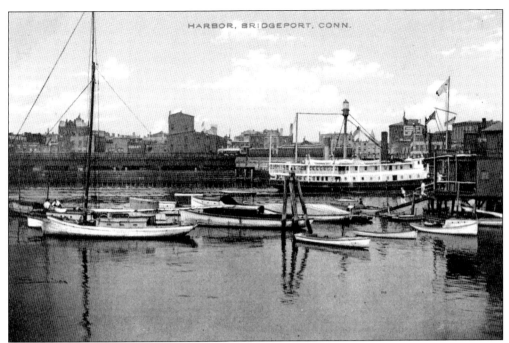

This harbor view postcard is looking west towards the central business district prior to 1912. On the left is the steeple of the South Congregational Church, and almost in the center of the picture is the grain elevator. On the right, two men can be seen walking down the ramp to the boats.

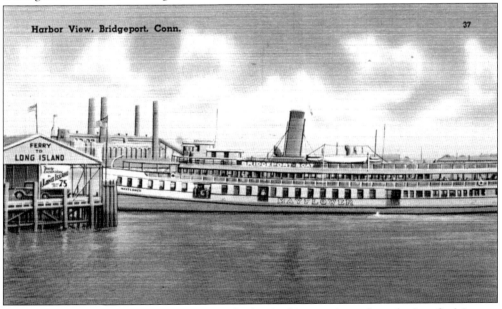

Harbor View, Bridgeport, Conn. 37

FERRY
TO
LONG ISLAND

A postcard from the 1930s shows Bridgeport harbor looking southeast from the Stratford Avenue bridge. The building on the left with the four smokestacks is the United Illuminating Company's steel point generating plant. Also shown is the ferry terminal building for the Bridgeport to Port Jefferson ferry. The steamer *Mayflower* is the large boat that dominates this photograph. The *Mayflower* made daily trips from Bridgeport to Battery Park Manhattan and Hoboken, New Jersey.

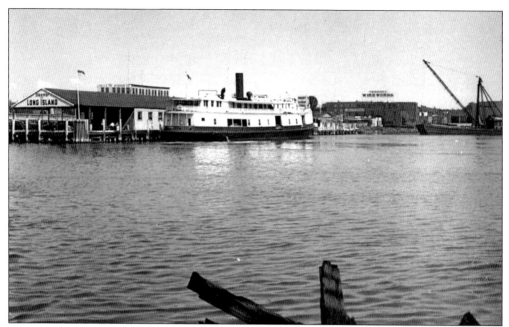

The Port Jefferson ferry is about to dock at the ferry terminal in this postcard from the early 1950s. The terminal building was located on Stratford Avenue not far from the bridge. On the right is the T.M. Barnes Wireworks factory, also on Stratford Avenue.

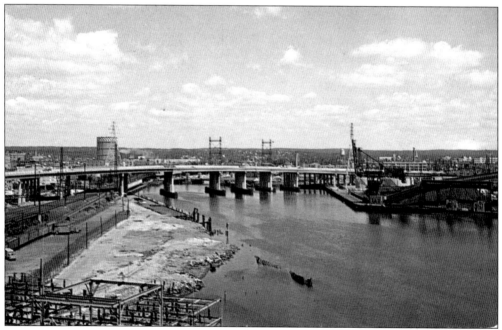

The Connecticut Turnpike bridge dominates Bridgeport harbor in this late-1950s postcard. Construction of the highway started in December 1956, and since its completion, it has removed much traffic from U.S. Route 1 in Bridgeport and other towns along this road. On the left is property of the United Illuminating Company, and closer to the turnpike is Union Square Dock, used by the Port Jefferson ferry since 1965.

Five

ADVERTISING POSTCARDS

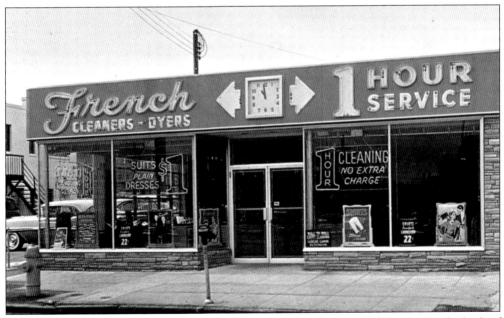

French Cleaners was located at 1957 Main Street opposite Commercial Street. On the back of the postcard is a listing of the 1950s era dry-cleaning prices, including 22¢ for shirts; 50¢ for pants, jackets, and skirts; and $1 for suits and dresses. The site is now a parking lot for Sunshine Hardwood Floors at the same address.

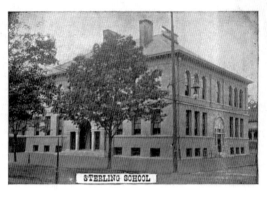

If your mother knew what pretty, inexpensive lawn dresses we have for girls and misses to wear at Graduation Exercises, she would gladly buy yours instead of making it. Ask her to see them at our store. Meigs & Co. Inc.

What looks like any other multiple view postcard is actually a clever advertisement from the Meigs and Company clothing store. This is one of a series of postcards that feature school buildings and handwriting on the front, reminding mothers of the pretty and inexpensive graduation dresses for sale at their store. This card features a rare view of the Sterling school as well.

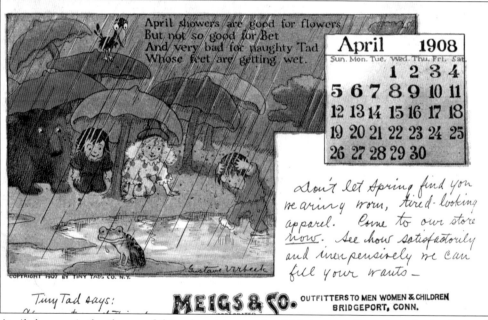

April showers is the theme of this advertising card, which is part of a series of calendar cards from 1908. Meigs and Company was a well-established clothing store located on the corner of Main Street and Fairfield Avenue. The postcard features an illustration by Gustave Verbeck and is signed by the artist.

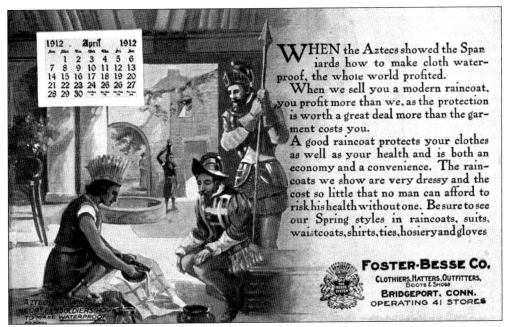

This postcard from the Foster-Besse store is part of a calendar series of cards from 1912 and also features rain as the theme for the month of April. The store was located at 956 Main Street opposite the City Trust building. The Foster-Besse store was a complete head-to-foot outfitter for men and boys and also sold shoes for the entire family.

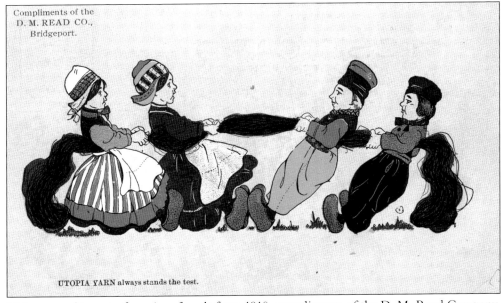

Compliments of the
D. M. READ CO.,
Bridgeport.

UTOPIA YARN always stands the test.

This postcard is part of a series of cards from 1910, compliments of the D. M. Read Company, showing the strength of Utopia yarn. D. M. Read was another retailer that was a Bridgeport landmark for many years and is no longer in business. The Bridgeport store was closed in 1989, and the remaining store in Trumbull became Macy's in 1993.

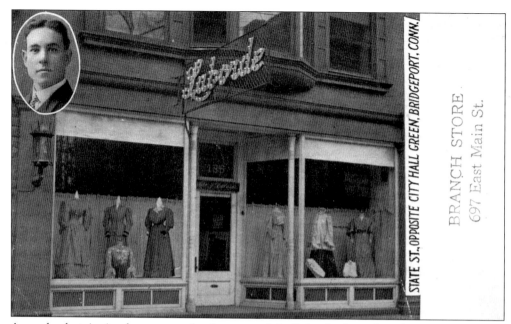

An early electric sign hangs over the doorway of the Laborde dress shop, located at 185 State Street in the Barnum Thompson building. George J. Laborde established his store in 1899 at 1115 Main Street and moved to State Street in 1904. This postcard features an inset photograph of the owner and is also stamped with the location of a branch store on East Main Street.

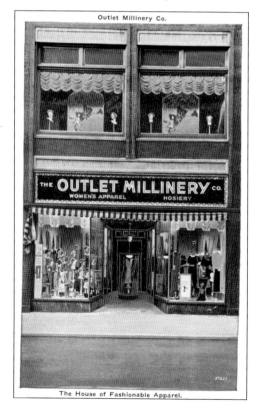

Outlet Millinery Co.

The House of Fashionable Apparel.

The Outlet Millinery store was located at 1105 Main Street south of Elm Street. Millinery stores sold hats and other articles to women and professionals in the business of designing, making, or selling hats, dresses, and hat trim to women. Additionally, stores such as this one sold new dresses and other women's articles.

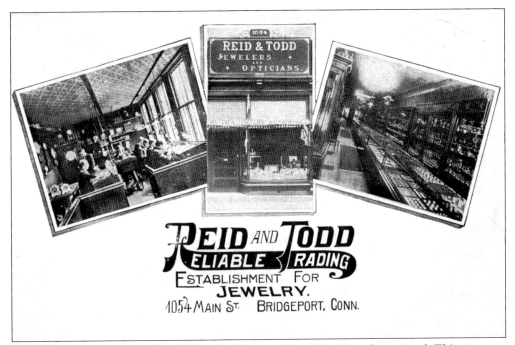

Three views of the Reid and Todd Jewelry Store are shown in this early postcard. This store was located at 1054 Main Street between Cannon Street and Fairfield Avenue. Established in 1883, Reid and Todd jewelers are still in business today and are located in Shelton.

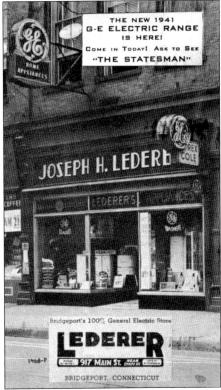

The Joseph Lederer appliance store was located at 917 Main Street where McLevy Green is today. It was here in this store in 1939 that the first television demonstration was given in the city of Bridgeport. He opened this Main Street store in 1937 and later moved to other downtown locations as he outgrew the smaller retail spaces. This card was mailed to a North Avenue address in 1941 to remind them that their General Electric refrigerator was 11 years old, and it was time to buy a new one.

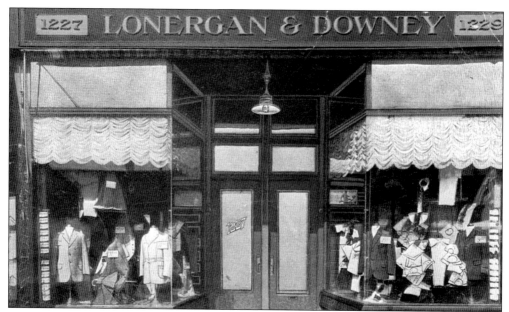

The Lonergan and Downey clothing shop, located at 1227–1229 Main Street, was one of the tenants in the Stratfield Hotel building. Edward Lonergan had nearly 20 years experience in selling men's clothing in Bridgeport before opening up his own store and adding a partner four years later. Most of the storefronts along Main Street, including this one opposite Elm Street, were remodeled over the years and lost a lot of their detail.

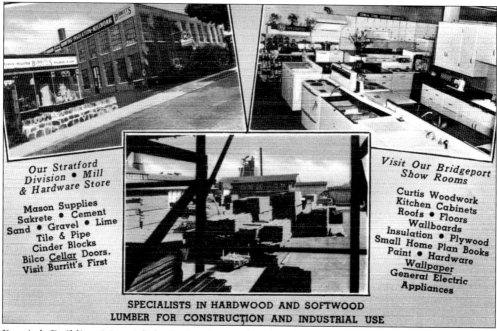

Our Stratford Division • Mill & Hardware Store

Mason Supplies
Sakrete • Cement
Sand • Gravel • Lime
Tile & Pipe
Cinder Blocks
Bilco Cellar Doors.
Visit Burritt's First

Visit Our Bridgeport Show Rooms

Curtis Woodwork
Kitchen Cabinets
Roofs • Floors
Wallboards
Insulation • Plywood
Small Home Plan Books
Paint • Hardware
Wallpaper
General Electric
Appliances

SPECIALISTS IN HARDWOOD AND SOFTWOOD
LUMBER FOR CONSTRUCTION AND INDUSTRIAL USE

Burritt's Building Materials had a lumberyard and mill, a hardware store, and an appliance showroom at its Bridgeport location. It was located at 360–540 Knowlton Street at the Grand Street bridge. The building it occupied has been vacant for a number of years. The Stratford division was at 1341 West Broad Street, which is now occupied by the Hudson Paper Company.

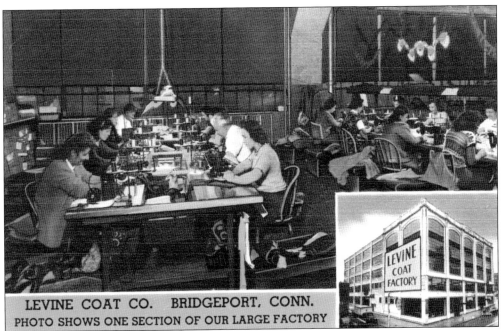

LEVINE COAT CO. BRIDGEPORT, CONN.
PHOTO SHOWS ONE SECTION OF OUR LARGE FACTORY

Women are hard at work in this 1958 postcard from the Levine Coat Company factory located at 27 Harrison Street. "Ladies: Why pay more?" proclaims the back of the card sent to a local woman in Bridgeport. Factory outlet stores such as Levine's offered real savings for their customers.

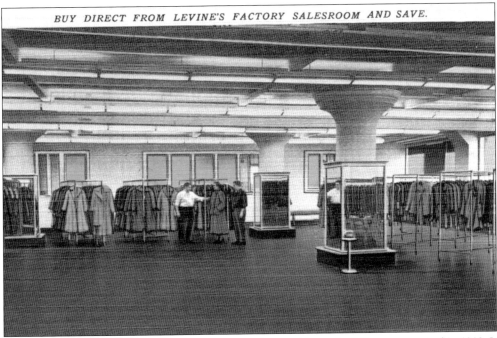

BUY DIRECT FROM LEVINE'S FACTORY SALESROOM AND SAVE.

The Levine Coat Factory was founded in 1932 and moved into a building constructed in 1919. It moved to Fairfield in 1983 after the building was sold. In 1985, the four-story factory building was gutted and converted into office space with an additional two floors added. Levine's closed its Fairfield store in 1990.

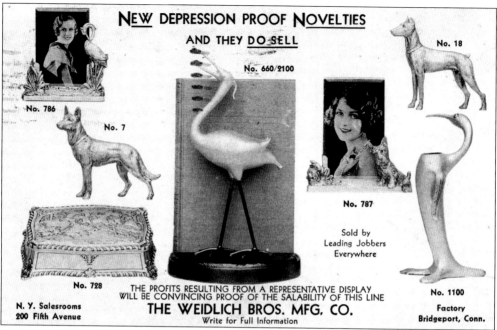

This postcard from the Weidlich Brothers factory was mailed in April 1933 in the midst of the Great Depression. The purpose of the card was to promote its line of novelties and convince retailers that their goods will sell, in spite of the tough economic times. The Weidlich Manufacturing Company is no longer in business, but the factory still stands today at 1313 Connecticut Avenue.

Bridgeport Centennial Commemorative Coin

There will be coined at a mint of the United States, to be designated by the Director of the Mint, silver fifty-cent pieces commemorating the 100th Anniversary of the incorporation of Bridgeport, Connecticut. Proceeds will be used towards defraying the expenses incidental to the celebration of this event.

Coins will be ready for distribution on or about September 1, 1936, by the First National Bank and Trust Company.

Applicants are limited to the purchase of not more than five coins.

Applications will be filled in the order of their receipt.

Each coin will be sold at $2.00 net. This includes the usual distribution charges. The market for these coins will be thoroughly protected. You are assured there will be no deviation from the above price.

Your inquiry has been referred to Charles H. Hurliman, First National Bank and Trust Company, Bridgeport, Connecticut, for further attention.

FINANCIAL COMMITTEE,
BRIDGEPORT CENTENNIAL, INC.,
STRATFIELD HOTEL, BRIDGEPORT, CONN.

23

In 1936, the city of Bridgeport celebrated its 100th anniversary. As part of the centennial celebration, a special commemorative coin was approved by congress. The silver 50¢ piece featured Bridgeport's most famous citizen, P. T. Barnum, on the obverse and an eagle of modern design on the reverse. These coins, which came in their own special boxes, are highly sought after today.

A postcard from the late 1930s featuring a larger-than-life billboard was a great way to promote the classified advertisements of the newspaper. Since 1925, the *Times-Star* operated out of the old Seaside Club building located at 928 Lafayette Street. The newspaper was abruptly closed down after being bought out by the rival *Post-Telegram* newspaper in 1941.

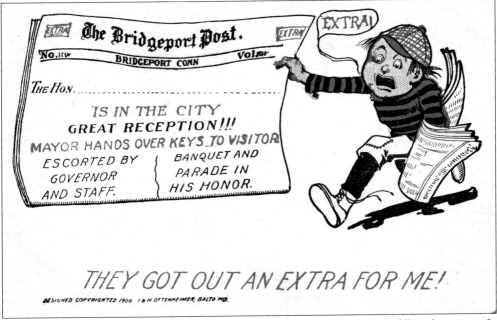

This is a clever advertising postcard from the *Bridgeport Post* from 1906. Just fill in the name of a person and mail it to them for a few laughs. Now known as the *Connecticut Post*, this newspaper has been keeping the Bridgeport area informed since 1883.

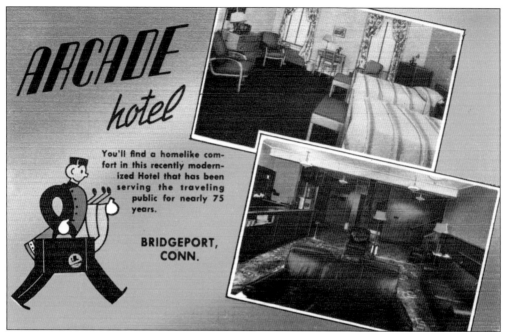

A great period postcard from the 1940s advertises the Arcade Hotel at 1001 Main Street. Excellent food and wine were served in the adjoining Commodore Grill and High Hat Bar. The world-famous Arcade Shopping Center was another feature of the hotel. The Arcade mall is currently undergoing restoration, and the hotel rooms are being renovated into apartments.

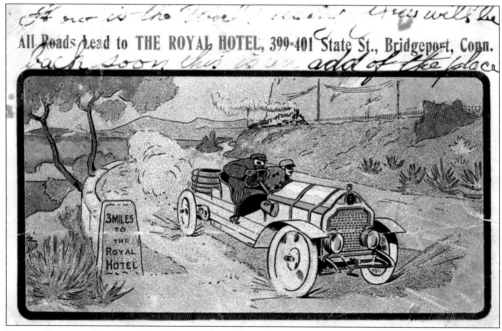

Postcards were effective advertising tools such as this one promoting the Royal Hotel on State Street. Only three miles to go proclaims the sign on this card sent to the Warner Brothers Corset factory in 1909. Could the passenger in the car be asking, "are we there yet?"

Poli's Theater had these cards printed to promote the appearance of the performing group Ten Holland Heinies in this undated postcard. When Poli opened the Palace and Majestic Theaters in 1922, the first Poli Theater on Main Street became known as the Globe—the theater where the Heinies probably made their appearance. Vaudeville shows remained popular even after the introduction of silent movies and talkies later on.

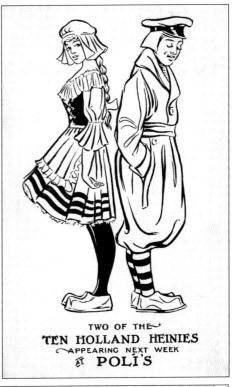

TWO OF THE
TEN HOLLAND HEINIES
APPEARING NEXT WEEK
at POLI'S

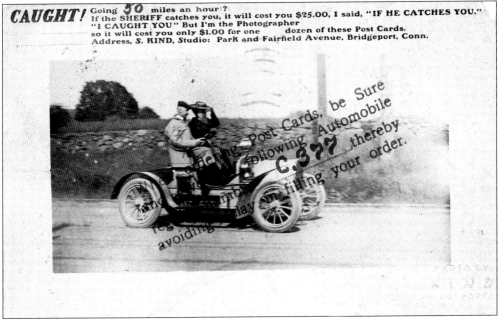

CAUGHT! Going *50* miles an hour (?) If the SHERIFF catches you, it will cost you $25.00, I said, "IF HE CATCHES YOU." "I CAUGHT YOU" But I'm the Photographer so it will cost you only $1.00 for one dozen of these Post Cards. Address, S. KIND, Studio: Park and Fairfield Avenue, Bridgeport, Conn.

Professional photographer S. Hind took sneak photographs of passing cars and mailed out sample postcards to the owners, whom he traced through the vehicle's registration. He charged $1 for a dozen copies of the postcard versus a $25 fine if caught speeding by a sheriff. Hind called automobiling "the greatest pleasure of modern times." His photography studio was located on the corner of Park Avenue and Fairfield Avenue.

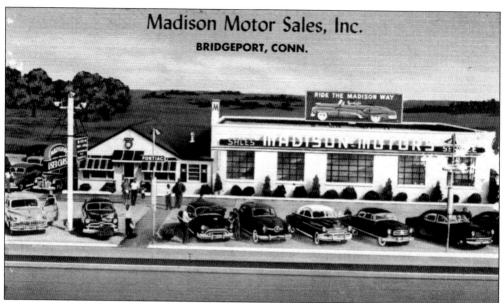

Madison Motor Sales was located at 2201 Fairfield Avenue on the southeast corner of Wordin Avenue. The billboard on top of the building encourages passerby to "Ride the Madison Way." Although Madison Motor Sales is no longer in business, the building remains standing and is still a used car business.

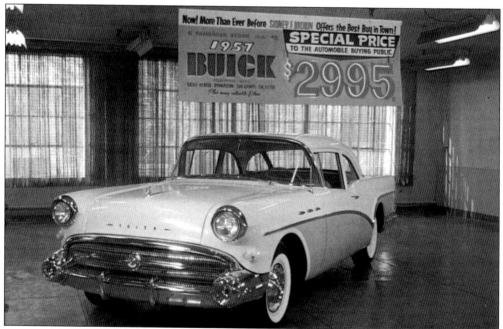

A brand new 1957 Buick Model 48 sits inside the showroom at a cost of less than $3,000. Connecticut's largest Buick dealer Sydney F. Brown was located at 1020 Fairfield Avenue until 1959. The dealership also sold used cars at its 470 North Avenue location. The Fairfield Avenue building was constructed in 1927 as a Packard dealership. In 1960, Hawley Hardware moved into the building from its previous location on Main Street downtown. Today the building houses a number of retail tenants.

Six

MECHANICAL AND MULTIPLE VIEWS

Monument to P. T. Barnum.

The P. T. Barnum monument is featured on the outside of this mechanical postcard published by W. I. Allen in 1905. Open the door, and 10 views of Bridgeport are on an accordion-style foldout. The following views are shown: the Spanish Cannon, the seawall, and soldiers and sailors monument from Seaside Park, the Rustic Bridge and the Casino from Beardsley Park, the Bridgeport Lighthouse, the Presbyterian church, St. Mary's Catholic Church, Washington Park, and Main Street.

The soldiers and sailors monument is on the cover of this unusual mechanical postcard also from local publisher W. I. Allen. Pull on a tab on the back of the card, and six scenes pop up, arranged in the shape of a fan. Shown are Steeplechase Island, Black Rock Point, the Falls and Rustic Bridge at Beardsley Park, the new railroad station, and the Spanish Cannon at Seaside Park.

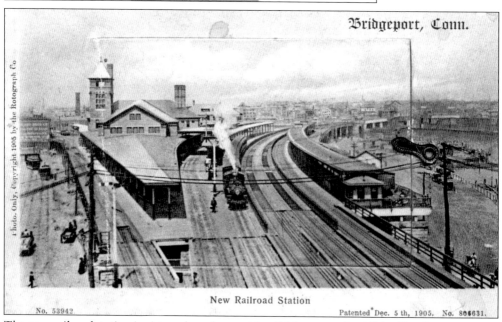

The new railroad station is pictured on the outside of this postcard published by the Rotograph Company in 1905. When the door is opened, an accordion foldout features 12 Bridgeport scenes. Some of the scenes shown are the Bridgeport Lighthouse, Main Street looking north, the Falls at Beardsley Park, Washington Park, the seawall at Seaside Park, the P. T. Barnum Monument, the Barnum Institute of Science and History, and the YMCA building.

Seeing Bridgeport, Connecticut, is an appropriate title for this postcard, which features 24 views in this complex mechanical card. When the card is opened, an antique car is pictured, and the accordion foldout is in place of the radiator. Some of the more rare views are a portrait of Barnum, the steamer *Bridgeport*, the winter home of Buffalo Bills' Wild West Show, the Barnum Institute of Science and History, and the winter quarters of the Barnum and Bailey Circus.

The Court Exchange building is on the cover, and an additional 10 snapshots of Bridgeport are seen one at a time by turning the wheel on this early mechanical postcard. The hidden pictures are the Locomobile factory, the lighthouse, the railroad station, city hall, the residence of Mrs. Nathanial Wheeler, the soldiers and sailors monument, St. Vincent's Hospital, the Howe Monument, the Protestant Orphan Asylum, and the entrance to Seaside Park.

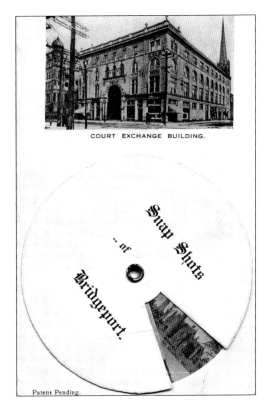

COURT EXCHANGE BUILDING.

Snap Shots of Bridgeport.

Patent Pending.

The inside of this 1907 postcard from F. W. Woolworth and Company features 24 views of Bridgeport in a seashell. Open up the shell, and an attached foldout tumbles down. Among the more rare views are the roller coaster at Steeplechase Island, the Congregational church, the police and charity building, the Fairfield County Courthouse, and the bathing beach at Steeplechase Island.

"Souvenir Greetings" is written on the outside of the book, and only when it is opened does one see that the greetings are from Bridgeport. The book holds 10 views, including the Court Exchange building, St. Mary's by the Sea, Steeplechase Island, the Seaside Park bandstand, the high school, Beardsley Park, the Elks Home, the railroad station, the lighthouse, and the lake in Seaside Park.

"Seen through a [camera] in Bridgeport, Conn" was an original idea for a mechanical postcard published by Simon's Camera Views in 1907. Twenty four views tumble down on an attached foldout when the camera is opened. Among the views inside are the old post office, Bridgeport Hospital, Lookout Point in Seaside Park, a harbor scene, the armory building, and Main Street looking north.

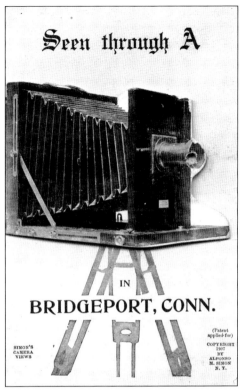

A classical figure holds an album in this art nouveau–style postcard from about 1904. Open the faux leather album cover, and inside are only four views of Bridgeport. These scenes are of the new railroad station, the Barnum monument, the falls at Beardsley Park, and the roller lift railroad bridge.

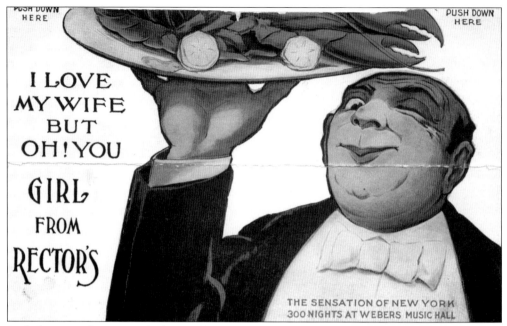

Push down on this postcard where indicated and out pops the beautiful showgirl from Rector's. "See the girl from Rector's coming soon at Jackson's Theater on October 8th," proclaims this undated private mailing card sent from the Main Street Theater.

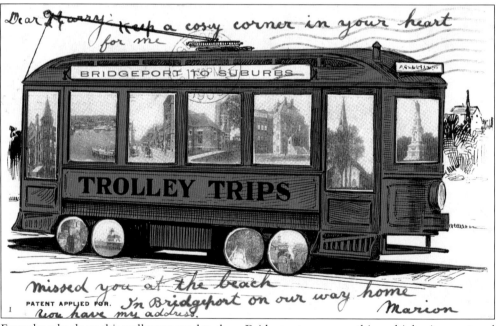

Even the wheels on this trolley are used to show Bridgeport scenes on this multiple view postcard from 1906. Partial views of the YMCA building, a harbor view, Main Street, the high school, St. Augustine's Church, and the soldiers and sailors monument are shown in the windows. The lighthouse, the rustic bridge, and new train station are shown on the wheels. One window scene and one wheel scene are unidentified.

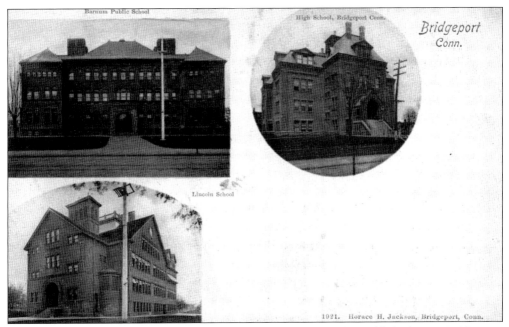

Horace H. Jackson owned a stationary store on Main Street and also published many Bridgeport postcards. He chose the Barnum Public School, Bridgeport High School on Congress Street, and Lincoln School on Stratford Avenue as the subjects in this early multiple view postcard. Only the Barnum school is still standing but without the top floor.

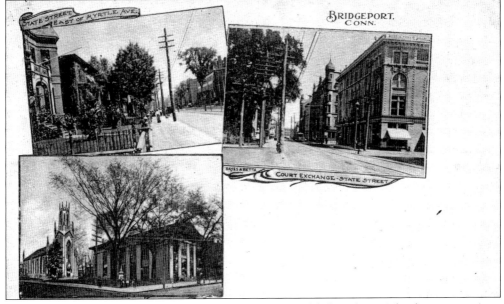

The publisher of this postcard is not identified but is most likely Jackson. The three street views are all located on State Street. The Route 8/25 expressway is now located where the top left photograph is, showing State Street looking east from Myrtle Avenue. The Court Exchange building and the Barnum Thompson building are still standing today as seen in the top right photograph. The First Congregational Church is long gone, but McLevy Hall still stands at the corner of State Street and Broad Street.

This postcard, published by A. Kleban and Sons in Bridgeport, reminds everyone that Bridgeport is the park city. The rose arch in front of the Beardsley Park Greenhouse is prominently displayed. Ten different scenes of the city are also partially shown inside the letters.

A similar postcard from publisher Nathan Schwartz and Son of Bridgeport is from about 1940 also. The Ann Hathaway Cottage in Beardsley Park takes up two of the letters, with the remaining ones all holding park scenes except for the *g*, showing Bassick High School, and the *p*, showing the General Electric plant on Boston Avenue.

A woman inside a pansy flower holding five
Bridgeport views brought "Greetings from
Bridgeport, Conn." in 1908. The views are
of the Irish Baptist Church, the lighthouse,
Bridgeport High School, Fairfield County
Court House, and the armory building.

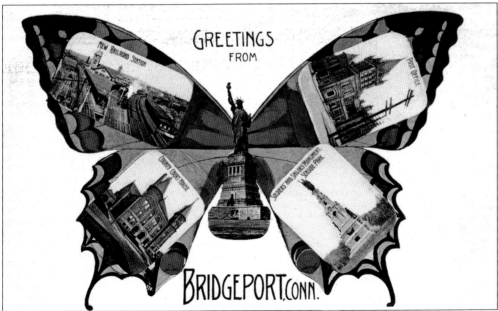

The Statue of Liberty in the center of the butterfly's wings seems out of place in this multiple
view postcard of Bridgeport. Similar cards from publisher I. Stern have Lady Liberty at the center
of the butterfly giving the cards a patriotic theme. On the wings are views of the new railroad
station, the old post office, the Fairfield County Courthouse before it was doubled in size, and
the soldiers and sailors monument in Seaside Park.

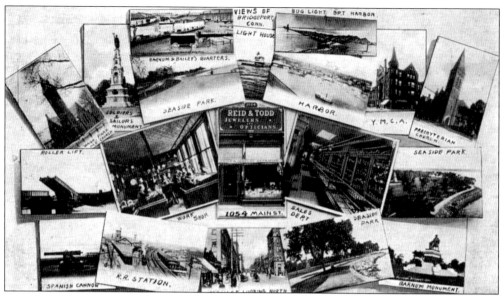

A total of 19 views are seen in this multiple view postcard from Reid and Todd jewelers. Note the three views of the jewelry store in the center of the card are the same ones seen in chapter 5. All of the other views seen in this postcard have been previously published individually as well.

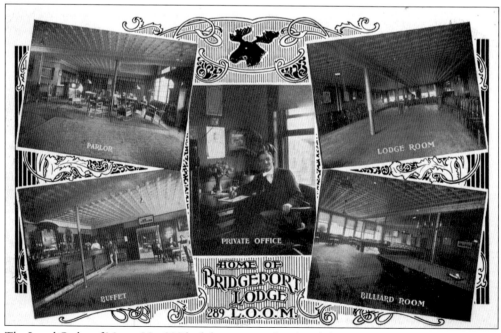

The Loyal Order of Moose No. 289 had these postcards printed showing interior views of its lodge from about 1915. The Moose lodge was located in rooms above the Empire Theater at 840 Main Street. Shown are the parlor, the lodge room, the buffet, the billiard room, and a private office.

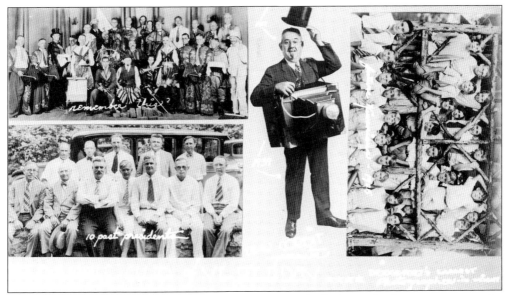

Photographer Lew Corbit was a Bridgeport institution who had a studio for many years on the corner of Main Street and Elm Street. This postcard from 1939 is promoting the Kiwanis Club's October meeting and also has Corbit poking fun at himself, proclaiming that he is Bridgeport's largest photographer in weight. Also shown is the year he was born—1917, a photograph of the past 10 presidents of the club, a group photograph from a show the club performed in, and a 1925 photograph of future members of the club.

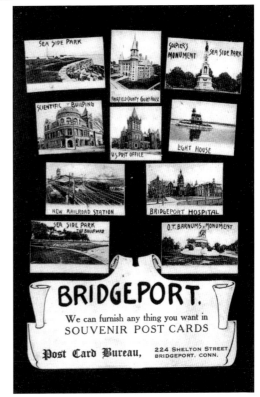

This multiple view postcard was used to promote the Post Card Bureau located at 224 Shelton Street. The undated card is from about 1910 when postcard collecting was very popular and many businesses catered to the hobbyists. Most of these postcards only have "Bridgeport" printed on the bottom, making this version of the card a rare one.

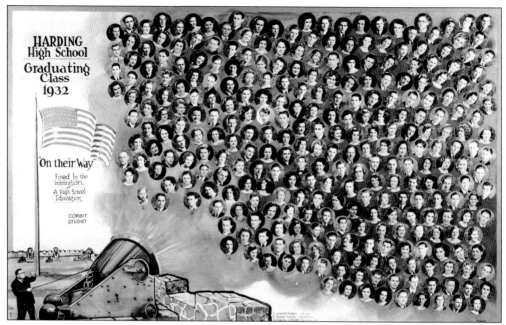

The Harding High School graduating class of 1932 had these postcards printed from Lew Corbit's studio. High school principal Ralph W. Hedges is seen firing the cannon on the left. He is identified in very tiny writing to the right of the wall. Also identified are Marion Maloney, valedictorian; Eldrich Gethright, president of the senior class; and Annette Zacchia, salutatorian.

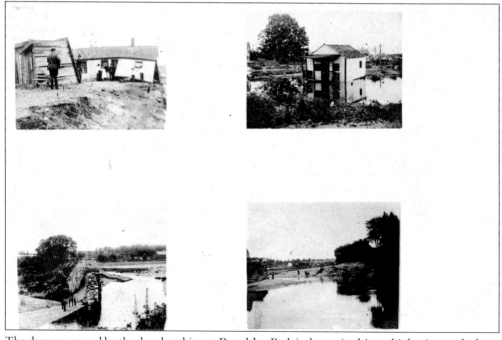

The damage caused by the dam breaking at Beardsley Park is shown in this multiple view real-photo postcard. The break was caused by over 11 inches of rain falling in just 16 hours. The photograph at top left shows a house carried by the floodwaters from North Avenue to River Street, a distance of a half-mile. This event occurred on July 29, 1905.

Seven

NOTABLE RESIDENCES

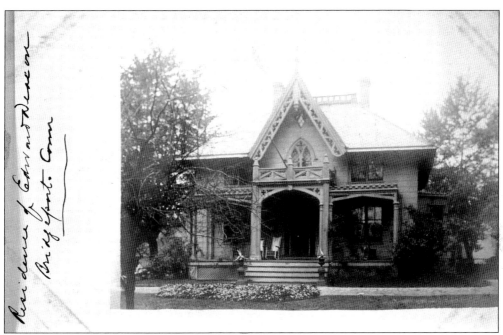

This real-photo postcard was taken in 1910 of the Gothic-style house still standing at 207 Grove Street. The architect was Alexander Jackson Davis, who also designed the Wheeler mansion. Edward Deacon, the owner of this house at the time, writes how he has lived in the house that used to be called Grove Cottage for 23 years. He complains that when he bought the house, the city's population was 47,000, and now it is 102,000. He also states that his house used to be in the country surrounded by farms, but now the city has grown up around it. Grove Street, which was originally known as Cooke's Lane, is named after this house.

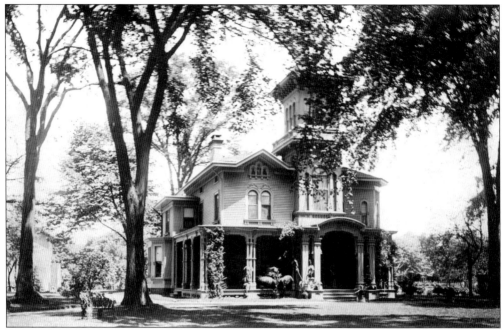

This beautiful mansion still standing at 528 Clinton Avenue has also seen many changes in the city around it. This house was built in 1852 and was first occupied by James D. Johnson. In 1868, the property was owned by C. A. Hotchkiss. The expansive property contained stables and also a vineyard. Clinton Avenue was known as Lincoln Avenue when this house was built.

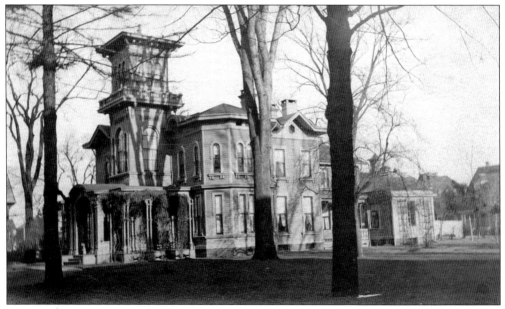

The top floor of the tower has since been removed from the house along with the front porch. Many homes like this in Bridgeport have had their towers altered as well. There are only a handful of houses remaining in the city with this type of tower intact. This was the home of the Bridgeport Art League for many years. Today this house is being used as a lawyer's office.

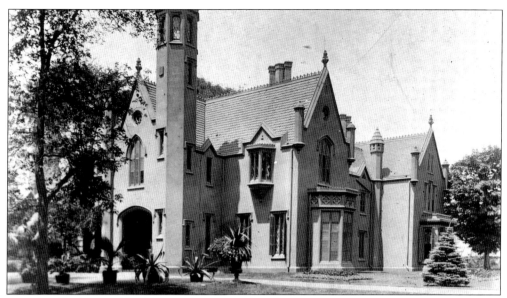

Henry Kollock Harral had this Gothic Revival–style mansion built as a gift to his bride, Sarah Ann Peet in 1848. This estate, bounded by Golden Hill Street on the south, Harrison Street on the west, and Congress Street on the north, sat atop Golden Hill. The address was 350 Golden Hill Street. Harral picked this spot to have his residence built because of a beautiful grove of black walnut trees growing on the property. Harral named the mansion Walnut Wood after the grove of trees. Nationally known architect Alexander Jackson Davis designed this incredible home.

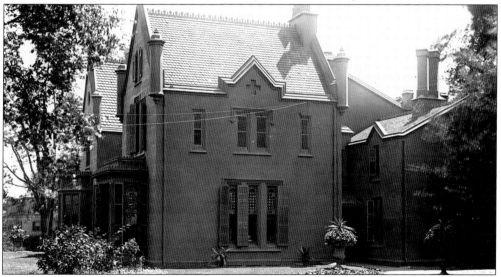

This real-photo postcard shows a rare view of the back of the mansion. Nathaniel Wheeler purchased the estate in 1866 after Harral's death. The original architect was called on to design an addition for the new owner. This view shows the addition built on the back side of the house, part of which contained a library. In 1956, the mansion was willed to the city when Archer C. Wheeler died. In 1958, the mansion was destroyed for the construction of a proposed new city hall/civic center that never was built. It was not torn down to build the Route 8/25 expressway. The highway cut through the northern part of the property eight years later and would have missed the house had it still been standing.

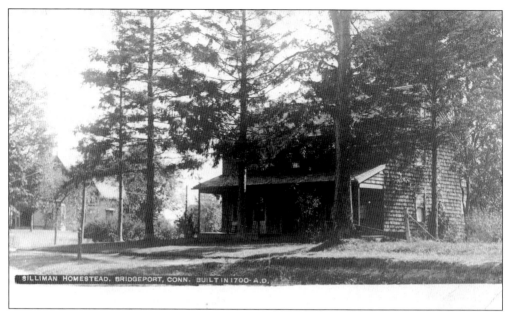

The William Pixlee house was constructed in 1700 on the southwest corner of Boston Avenue and East Main Street diagonally across from Old Mill Green. This section of Bridgeport was still a part of the town of Stratford at the time it was built. In 1780, the grandson of the original owner converted the house into a tavern, and it was known as Harpin's. The Silliman family owned the property when this photograph was taken in 1903.

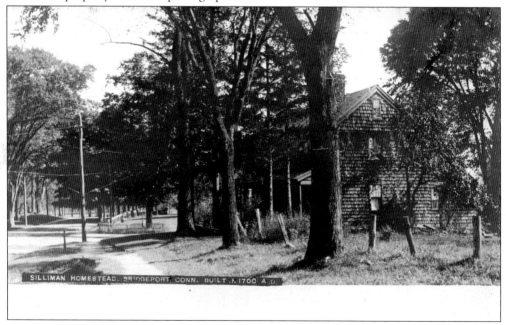

This postcard shows a slightly different view of the Pixlee house and also dates from 1903. In 1978, there was talk of demolishing or moving the house for a commercial development. Luckily the house was dismantled, put into storage, and later erected on Cedar Road in Fairfield in 1979. The Old Mill branch of the Bridgeport Public Library along with a few restaurants and stores occupies this site today.

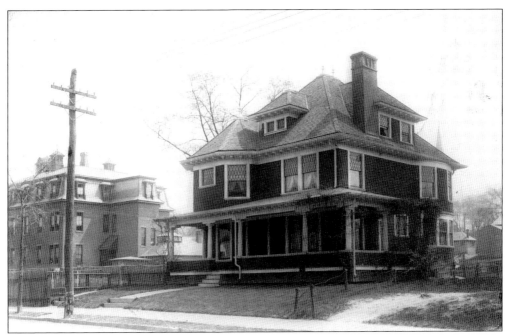

A postcard dated June 15, 1911, shows the sender's house at 246 Vine Street with the message reading, "This is our house; why not come and see it." The house has been torn down and is now part of the parking area for St. Augustine's Cathedral. The brick building seen on the left is the back of Washington School located on the southwest corner of Pequonnock Street and Vine Street. Washington School was built in 1860 and was torn down by the city in 1975 for a park.

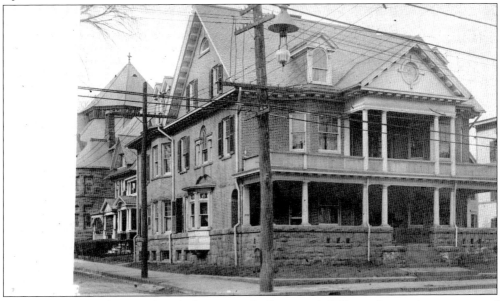

This brick Colonial Revival–style house was built around 1910 on the northeast corner of Fairfield Avenue and West Avenue. To the left can be seen part of the First Baptist Church on the corner of Washington Avenue. Today the brick house on the corner is still standing and is being used as a rooming house.

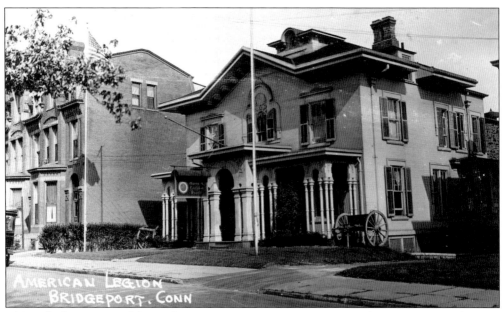

This real-photo postcard shows the American Legion Harry W. Congdon Post No. 11. This post was founded in 1919, and in 1920, it moved into the Peter M. Thorpe house built in 1850 at 307 Golden Hill Street. After 1920, the American Legion modified the facade by adding a large overhang with pillars. The house, currently being remodeled by Kuchma Builders, has recently removed these earlier modifications from the facade. The brick row house on the left was built in the late 1870s and was modernized and made into office space some time ago. Recently this structure was torn down, and a small park was put in its place.

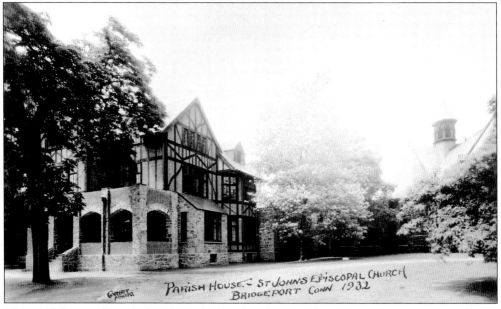

The parish house of St. John's Episcopal Church is shown in this postcard from 1932. This house, located next to the church on Fairfield Avenue, was built in the 1870s at about the same time as the church. This postcard from Lew Corbit's studio shows the parish house newly remodeled in the English Tudor style. St. John's Church has recently torn down this parish house.

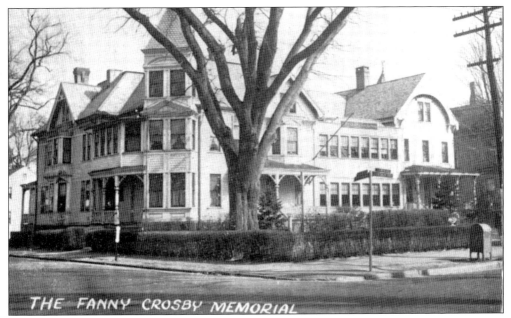

THE FANNY CROSBY MEMORIAL

Fanny Crosby was a blind hymn writer, preacher, and lecturer who died in Bridgeport on February 12, 1915. Before she died, she stated, "Should a memorial ever be raised in her honor, she wanted it to bring active good and happiness to living people." In 1925, the Fanny J. Crosby Memorial home for the aged opened at 1088 Fairfield Avenue on the northeast corner of Sherwood Avenue. It is now known as the Bridgeport Rescue Mission.

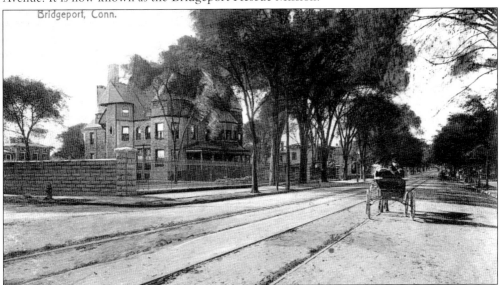

This postcard shows Park Avenue looking north from the intersection of Garden Street. On the left is the residence of Col. Nathan Heft. This house cost $125,000 to build in 1889. Heft was an engineer who installed the first electric streetcar system in Bridgeport. He brought over artists from Italy who painted murals and frescoes on the walls and ceilings of this 20-room ornate Victorian mansion. Park City Hospital was founded in this mansion in 1924. The hospital later expanded and built alongside the mansion. This imposing edifice was torn down in 1966 to build a new hospital wing.

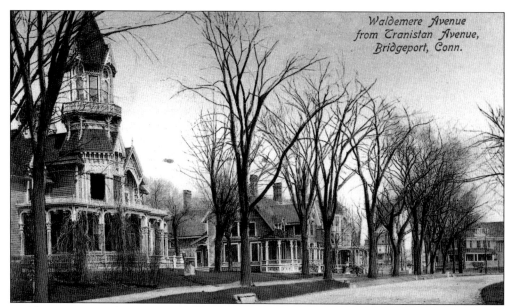

Waldemere Avenue looking east from Iranistan Avenue is shown in this postcard view. On the left is one of the cottages built by P. T. Barnum for his daughters. The name of this cottage was Idlesse. It was built in the same style as the main house, complete with a tower but on a smaller scale. These cottages were part of Barnum's Waldemere estate. The estate was bounded by Park Place on the north (now University Avenue), Park Avenue on the east, Waldemere Avenue on the south, and Iranistan Avenue on the west.

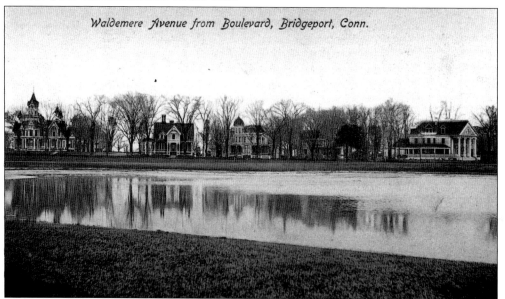

Waldemere Avenue is seen in this postcard view looking north from Barnum Boulevard in Seaside Park. Looking from left to right, one can see the cottages that Barnum built on his estate for his three daughters, all married, including Idlesse, built for Pauline Seeley; Petrel's Nest, built for Carolyn C. Thompson; and Beachcroft, built for Helen B. Hurd. Idlesse was torn down in 1912, Petrel's Nest was torn down in 1915, and Beachcroft was torn down in 1938. The house on the right with the pillars was built for Dr. Virgil B. Gibney in 1910.

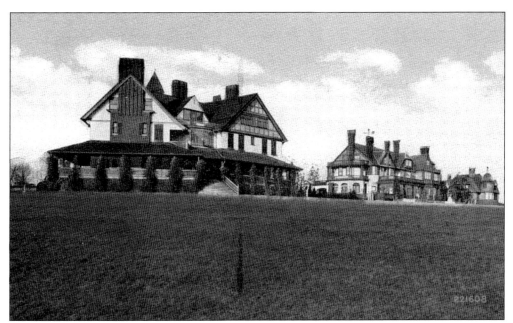

The Pearsall, Thorne, and Watson homes in Black Rock are shown in this postcard view from 1908. These three mansions were built as summer homes around the same time in 1881 and were located south of the famous George Hotel. The property of the Pearsall estate on the left included the sandy beach on Black Rock Point. Here he built St. Mary's Chapel for his wife. The three mansions on the point were later demolished with smaller modern homes built in their place.

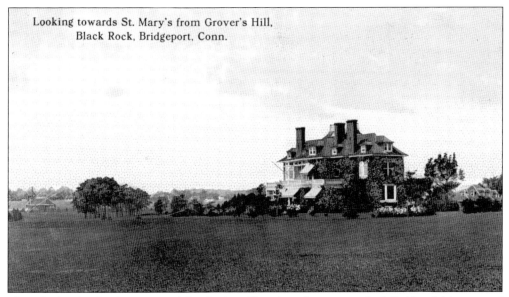

If one looks closely, the St. Mary's by the Sea Chapel can be seen on the left side of this postcard from about 1908. Spofford Pearsall was the son of Thomas Pearsall, whose home is shown in the postcard above. Spofford had the house shown in this postcard built to the west of his father's estate and lived there until 1918. The house is still standing today, and the address is 37 Eames Boulevard.

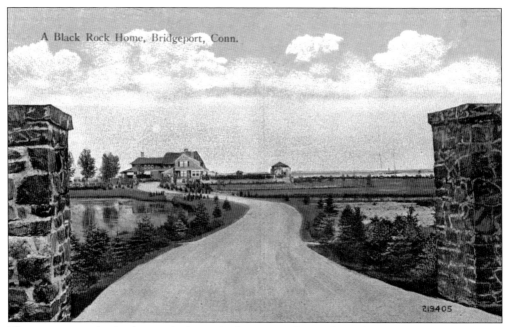

The entrance to the Anchorage is shown in this postcard view from about 1910. This waterfront estate was built in 1904 and was first owned by J. Percy Bartram. The main house was built on the shore, and the property featured a pool, a pond with a bridge over it, a rose garden with trellises, and a private wharf for Bartram's 160-foot yacht *Caritas*.

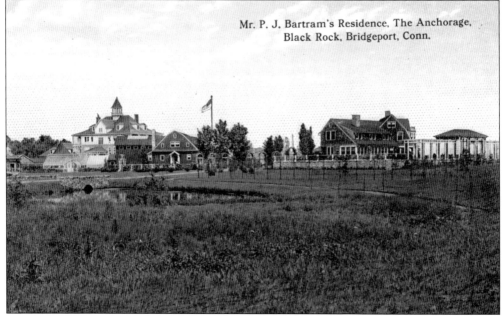

The Bartram estate bordered the Bridgeport Yacht Club at the time this photograph was taken. The yacht club building is the one seen on the left with the cupola on the roof. The Bartram house is on the right. In the 1930s, Franklin Delano Roosevelt was a guest at the estate. The owner of the house at this time was Archibald McNeil. The original Bartram residence is still standing today and is located at 98 Grovers Avenue.

Eight

RESTAURANTS AND A LITTLE RECREATION

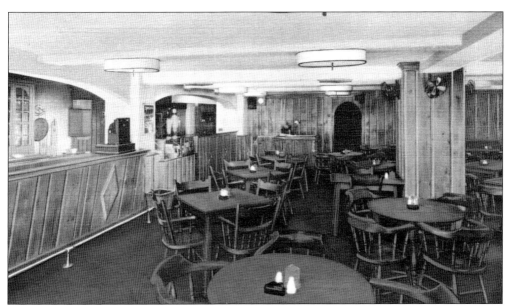

The dining room of the pine room bar and grill is shown in this postcard from the late 1930s. This restaurant was built as part of the large wing added to the Stratfield Hotel in 1927. The pine boards shown in the postcard came from a barn built in Redding in the 1780s. This barn was taken down in the summer of 1933, and the wood, which had never been painted, was reused here. The wood was not stained and was left natural. Today this is the home of Carmelina's Restaurant, located at 57 Chapel Street. Some of the pine is still on the walls but has been painted over.

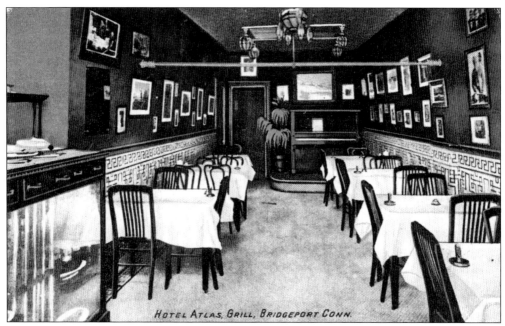

The main dining room of the Hotel Atlas featured an upright piano at one end of the room. Prof. James M. Atlas built this hotel, located at 247 Fairfield Avenue, in 1910. The hotel featured an indoor swimming pool and Turkish baths.

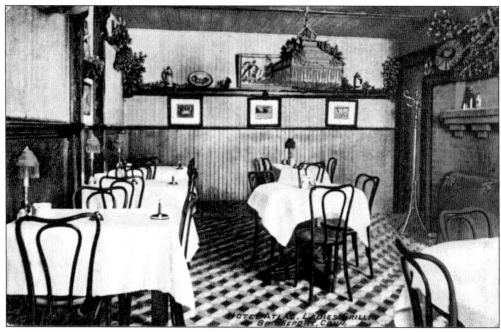

The Hotel Atlas had a separate dining room for women, as this was the custom at the time of this postcard from about 1912. A large fireplace adorns one wall of this nicely decorated restaurant. This hotel, an early health spa, was torn down in October 1933.

The Hotel Howard was located at 577 Howard Avenue between State Street and Railroad Avenue. The hotel opened in 1896 and consisted of 50 rooms. In 1940, the hotel was purchased by Martin A. "Matt" Lucey, who owned it until his death in 1967. The building was torn down in 1968 after two major fires occurred within a six-month period.

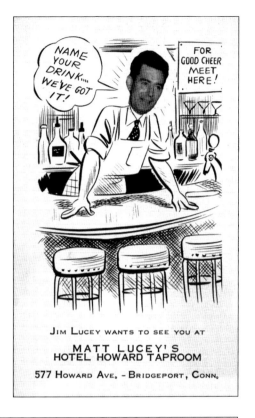

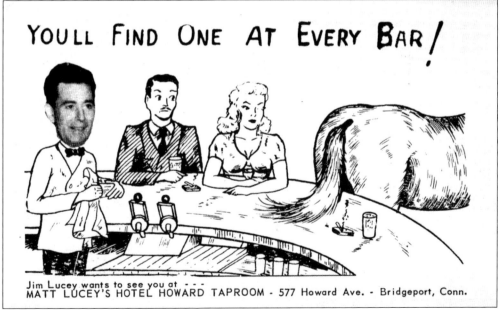

There can be no doubt that the taproom at the Hotel Howard had seen many colorful characters over the years. Shown on both postcards is Jim Lucey, who was the bartender and also the brother of owner Matt Lucey. This advertising postcard features a hilarious illustration of a horse's ass at the bar with some hapless guy's date winking at it.

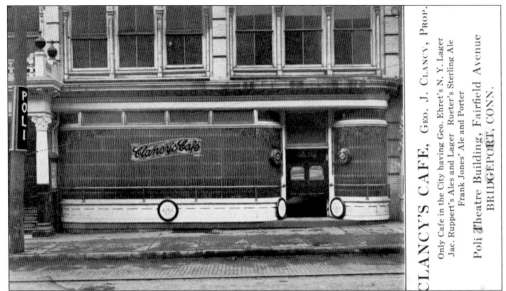

CLANCY'S CAFE, Geo. J. Clancy, Prop.

Only Cafe in the City having Geo. Ehret's N. Y. Lager
Jac. Ruppert's Ales and Lager Rueter's Sterling Ale
Frank Jones' Ale and Porter

Poli Theatre Building, Fairfield Avenue
BRIDGEPORT, CONN.

Clancy's Café was located at 45 Fairfield Avenue in the Poli Theater building. This business, owned by George J. Clancy, opened in 1910 and was sold to J. A. Morse in 1913. The ornate theater building was constructed as the Hawes Opera House in the 1870s. This became the Poli Theater in 1902 and was called the Plaza Theater after 1912. This building was demolished in 1930.

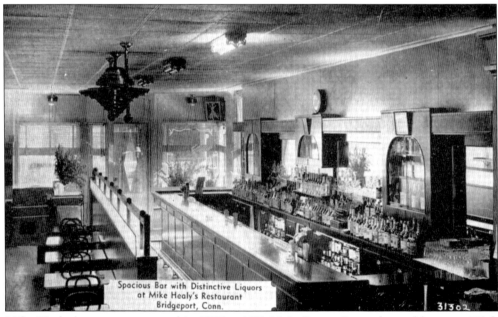

Spacious Bar with Distinctive Liquors
at Mike Healy's Restaurant
Bridgeport, Conn.

31302

Mike Healey's restaurant opened in 1947 at 1411 Main Street. It was located between High Street and Fulton Street across from the Lyric Theater. In 1941, Mike Healey was the president of the Bridgeport Full Permit Liquor Dealers Association. In 1952, the Brass Rail restaurant opened in this location.

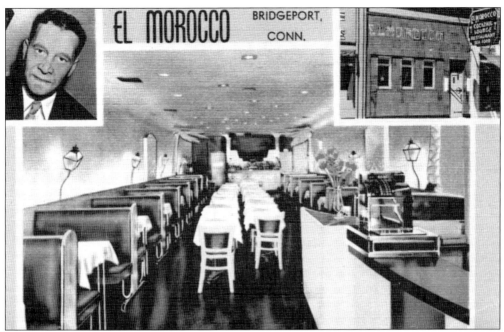

The El Morocco Restaurant, owned by S. R. Laquessa in the inset picture, opened in 1947 at 1277 Main Street between Chapel and Congress Streets. This restaurant promised atmosphere in a restful place to dine, making every visit a pleasant memory. Prior to this, the Iron Gate Restaurant was located at this address. The El Morocco closed in 1955, and the Casbar Restaurant opened in its place.

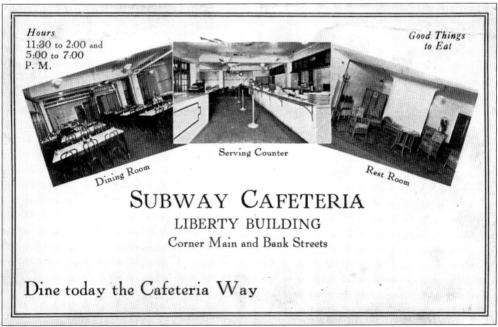

The Subway Cafeteria was aptly named being located in the basement of the Liberty building at 943–951 Main Street. Charles G. Lincoln was the proprietor of this short-lived restaurant. The Subway opened in the newly constructed Liberty building in 1919 and closed by 1923.

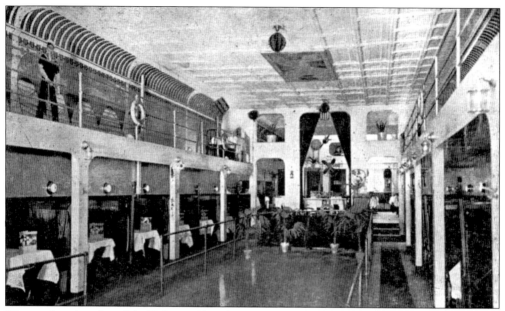

The spacious interior of the Belmont Showboat restaurant is pictured in this 1930s-era postcard. The Belmont was located at 923 Main Street in the Sturdevant building, now a part of McLevy Green. This restaurant was advertised as the most popular place of its kind in Connecticut with the finest in food and liquors as well as the ultimate in entertainment. The Belmont Showboat did not last. It opened in 1936 and closed by 1939.

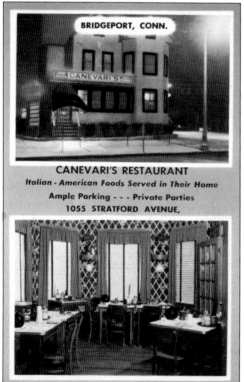

Canevari's Restaurant was located at 1055 Stratford Avenue between Fourth and Fifth Streets. Angelo Canevari opened this restaurant in 1953 in his own home, inviting patrons to "dine with us in a homelike atmosphere." By 1957, this establishment had closed and the Tai Pan Low restaurant had taken its place.

The Schnitzelbank Restaurant was located at 259–261 Stratford Avenue between Kossuth Street and East Main Street. It was the largest and most unique Bavarian restaurant in New England, and maybe even on the Atlantic coast. The nightly entertainment featured singers, dancers, and even yodelers. An animal park built in a Bavarian village setting was also located on the property. Despite all these features, the Schnitzelbank was short-lived, opening in 1936 and closing by 1939.

MAESTRO ALFREDO and his MERRYMAKERS
Singing the famous "SCHNITZELBANK"

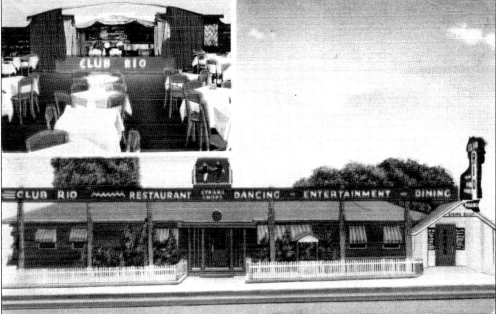

The Club Rio was advertised as being located in the heart of Bridgeport just 100 yards from the train station. The site at 259–261 Stratford Avenue was home to the Timber Inn Restaurant in 1935, the Schnitzelbank Restaurant from 1936 to 1939, the Swiss Village Restaurant from 1940 to 1947, and the Club Rio from 1948 to 1958.

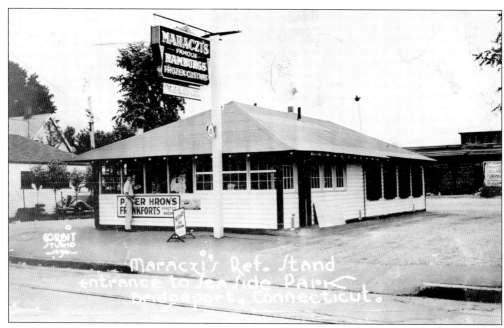

The Maraczi's refreshment stand opened in 1934 at 110 Main Street at the entrance to Seaside Park. This hamburger stand was located next to the Bug Light bar and grill. Maraczi's closed its small stand in 1941, and the family took a few years off before opening up a larger restaurant on Boston Avenue in 1950.

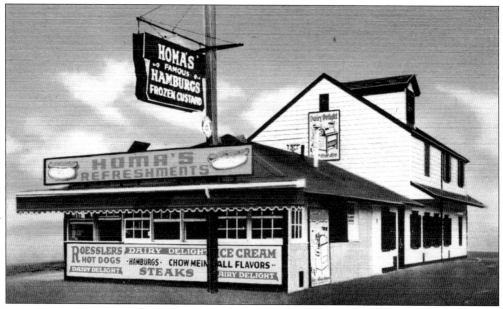

Homa's refreshment stand opened in 1942 in the building previously occupied by Maraczi's. The most noticeable change the new owners made was the large addition constructed in back of the original building. In 1970, the name was changed to Homa's University Drive Inn since many of its customers were students from the University of Bridgeport. By 1988, Homa's had closed, but the building remains standing behind a chain-link fence, now a part of the vacant Remington property.

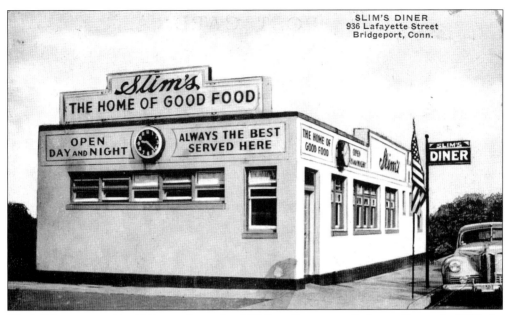

Slim's Diner, opened in 1941, was located at 372 State Street near Lafayette Street. In 1949, the business moved to 963 Lafayette Street, misidentified on the postcard as 936, on the northeast corner of State Street. The name was changed to the Lafayette Diner at the time of the move to the new address. This diner closed in 1965 when this area was redeveloped and Lafayette Street was widened to create Lafayette Boulevard.

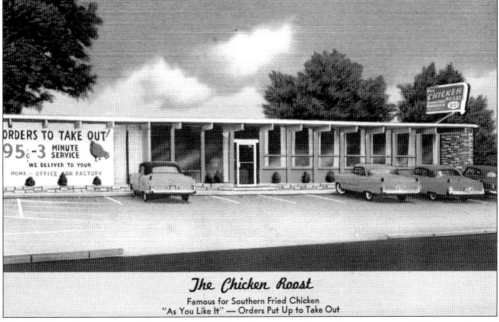

The Chicken Roost opened in 1956 at 978 State Street on the northeast corner of Norman Street. The restaurant featured ham and eggs or bacon and eggs served New York style in the skillet as well as its famous Southern fried chicken. In 1981, the Drumstick Barbeque Restaurant opened in the same building. Today a small strip mall of stores occupies the site.

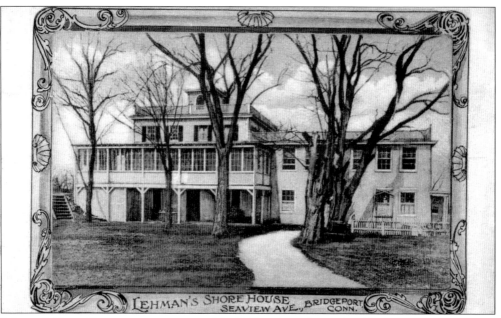

Lehman's Shore House restaurant opened in 1899 and was located at 197 Seaview Avenue near Central Avenue. The original name of the restaurant was the Lewis Shore House, which was built on the waterfront in 1890. The owner of the Lewis Shore House was Otto Lehmann, who later changed the name of the restaurant and owned it until 1922 when Stephen P. Kish became the proprietor. When Lehman's Shore House restaurant closed down by 1934, it was owned by Matt Lucey, who later bought the Hotel Howard.

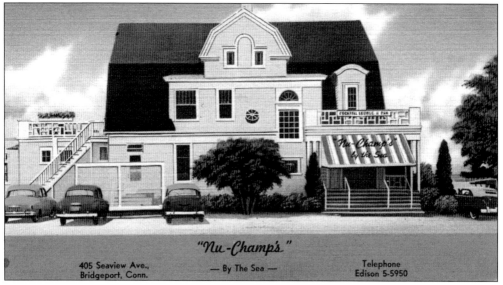

Nu-Champ's by the Sea opened in 1936 and was located 405 Seaview Avenue overlooking Long Island Sound. The menu included broiled lobsters, steaks, and chops, and it was open for lunch, dinner, and cocktails. Additionally dancing was featured every Saturday night. Prior to 1936, this restaurant was known as the White House Inn. Nu-Champ's closed in 1959, and Bru Conte's Riviera opened in its place in 1960. This structure is still standing, although it is no longer a restaurant.

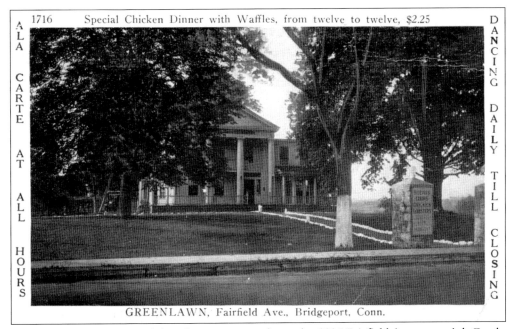

GREENLAWN, Fairfield Ave., Bridgeport, Conn.

The Greenlawn Country Club and restaurant was located at 3336 Fairfield Avenue on Ash Creek. This grand mansion was built in 1835 for Robert Moran and went through many different owners. The Greenlawn opened in 1919 but had closed down by 1922. The house was vacant for a few years and burned down in 1925.

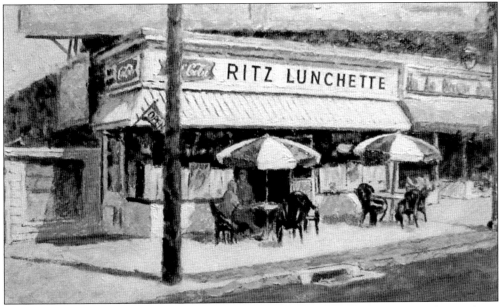

The Ritz Lunchette opened in 1962 and was located at 2816 Fairfield Avenue on the northeast corner of Brewster Street. The limited space on the sign could be a possible explanation for the spelling. John Ratzenberger of the television show *Cheers* worked here as a soda jerk while a teenager. The late Dave Macdonald bought the Ritz in 1992, and is the donor of this postcard. After Macdonald sold the business, the name of the restaurant was changed to Matty's Corner, a neighborhood bar.

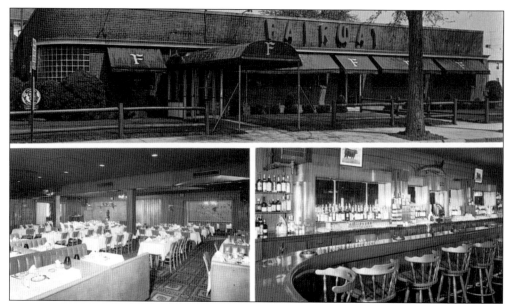

The Fairway Restaurant was built as a nightclub in 1935, and the address was 2536 East Main Street on the corner of Louisiana Avenue. It was destroyed by fire in 1941 and rebuilt. Many famous performers appeared on stage here, including Dean Martin, Milton Berle, Alan King, and Buddy Hackett. The Fairway later dropped the nightclub, and the business was a restaurant only. Fitzwilly's moved into the building in 1981 and served great food here for about 20 years. Today the building has gone back to its roots and is a nightclub once again, known as the Sixx Night Club.

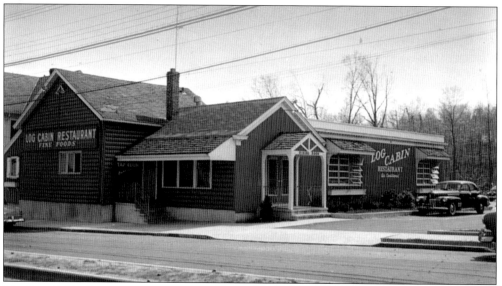

The Log Cabin Restaurant opened in 1954 and was located at 4485 Main Street. The building was an actual log cabin built before the Civil War. In 1904, the place was known as Fritz Hanninger's Café, nicknamed "automobilist rest." Located at the bottom of lengthy Ox Hill, early travelers stopped here to rest and have a bite to eat or a drink. The building was torn down in the late 1960s, and a new restaurant was constructed at the same address now occupied by Red Lobster.

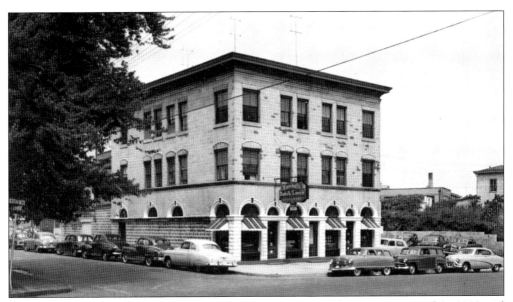

Kunkel's Restaurant was one of the oldest restaurants in Bridgeport. It opened in 1888 and was located at 1282–1284 North Avenue on the northeast corner of Center Street Extension. In addition to the restaurant, Kunkel's sold hay, grain, feed, meats, and groceries all under one roof. This only lasted for a few years after first opening however, and it soon dropped the other businesses and concentrated on just the restaurant. In 1983, Minabela, a Portuguese restaurant, moved in. Today the building is the home of Terra Brasilis, a Brazilian restaurant.

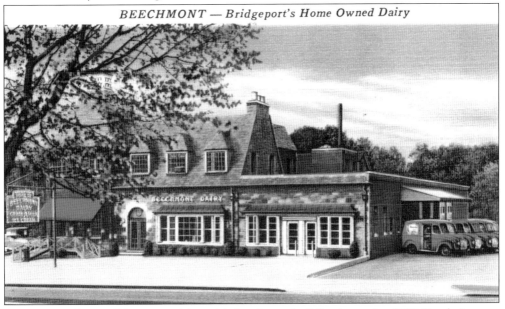

In 1937, Beechmont Diary moved into this handsome building located at 2710 North Avenue. Prior to this in 1936, the building was the home of Superior Dairy. Beechmont was one of many dairies that were once located in Bridgeport. In the retail and wholesale business for many years, the Beechmont Dairy closed by 1973. Afterward several different businesses moved into and out of the building. By 1985, the Butler Business School moved in and still occupies this building today.

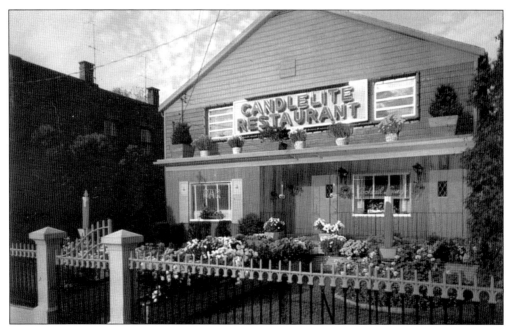

The Candlelite restaurant, located at 246 River Street, opened in 1946. This restaurant featured a large terrace overlooking Candlelite Stadium located in the back. The restaurant was also noted for its large banquet facilities with seating for up to 1,200 people. In 1971, the business was sold, and the name was changed to DeNitto's villa. The building was torn down in the 1980s.

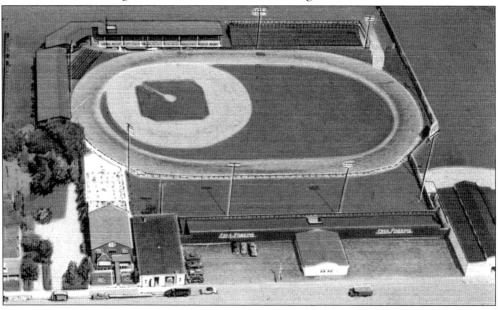

Candlelite Stadium, opened in 1948, was located at 248 River Street. This was the former site of the City League Club. Sporting events of all kinds took place here, including baseball, basketball, boxing, rodeo, automobile races, wrestling, thrill shows, and special events. This facility had a maximum capacity for 20,000 people. Midget automobile racing was very popular here with many accidents occurring, some resulting in fatalities. In 1955, the Candlelite Pix Twin drive inn theaters were built on this site.

Roller-skating was very popular at the time this postcard was sent in 1908. The Park City Skating Rink was located at 1075 State Street. The sender of this card informed her friend that Bridgeport had two other rinks besides this one on Steeplechase Island and also on North Avenue called the Gem Rink. The Park City Skating Rink opened in 1907, and by 1914, it was out of business. This rink is not to be confused with the roller-skating rink that later opened inside the Pyramid Mosque building, whose address was at 1035 State Street.

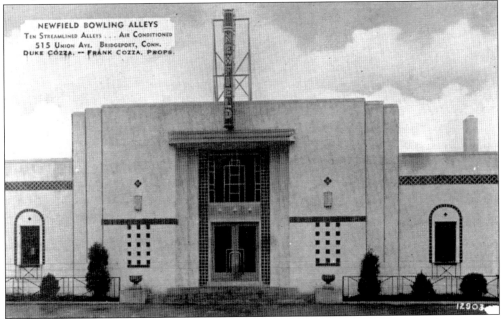

The Newfield Bowling Alley was located at 515 Union Avenue just north of Stratford Avenue. It was built in 1921 on the site of Roman Theater, which later became the East End Theater and eventually the Imperial Theater. The Newfield Bowling Alley was in business a long time and closed down by 1968. The building is still standing and has been used as a place of worship.

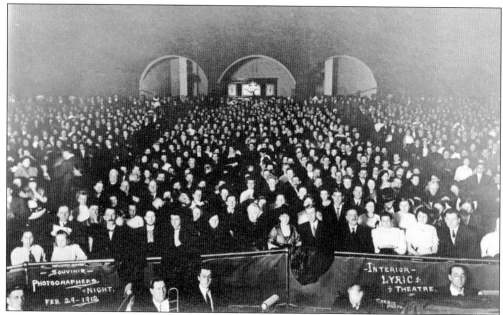

This rare photograph by Lew Corbit's studio shows the interior of the Lyric Theater located at 1426 Main Street. The occasion was the souvenir's photographer's night that took place on February 29, 1912. Note the orchestra in the foreground of the picture. The theater, which opened in 1911, closed in 1932 and reopened in 1933 as the Loew's-Poli Lyric Theater. By 1957, it closed for good with the building later being demolished.

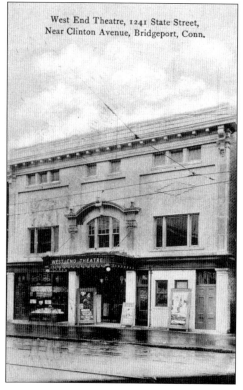

The West End Theater was located at 1241 State Street near Clinton Avenue. The theater opened in 1910 and was one of many small neighborhood theaters in the city. In 1966, the movie house was renamed the San Juan Theater, reflecting the neighborhood's increasing Spanish population. By the mid-1970s, the theater closed and has since been taken down.

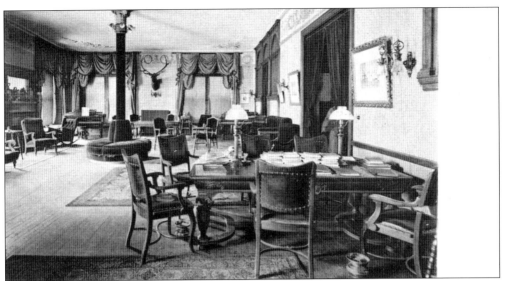

Beautiful period furnishings adorn the interior of the Algonquin Club, organized in 1893. The interior shown is of the clubhouse when it was located at 211 State Street in the Court Exchange building. In 1931, the Algonquin Club moved to 385 Golden Hill Street where it remained for over 30 years. In 1965, the club moved once again when the construction of the Route 8/25 expressway claimed that section of Golden Hill Street. A new building was built at 970 Lafayette Boulevard. This building was torn down, and a 10-story tower was built in its place with the club occupying part of the tower. The Algonquin Club disbanded around 1998.

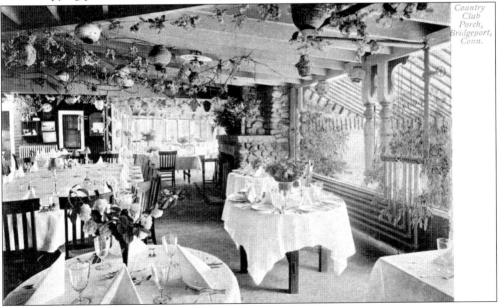

Opening day for the Brooklawn Country Club was on May 1, 1895. The club, formed by leaders in the business and social life of the city, wanted to promote outdoor and indoor sports in Bridgeport. The club got its start with the purchase of the Spooner farm on Collingwood Avenue in Fairfield. The farmhouse became the clubhouse, a barn was converted into a locker room, and another barn was converted into a dancing casino and game room. In June 1916, the present spacious clubhouse was opened, which continues to serve the club members today.

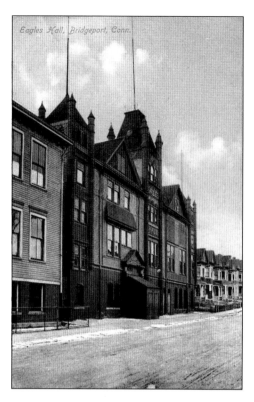

The Eagles Hall was located at 65–67 Madison Avenue near Washington Avenue. Its lodge building shown here was constructed around 1890. After the Eagles moved out in 1929, the building became the Red Man's Hall. In later years, the Colored Civic Club was among the clubs that later occupied the hall. The building was torn down around 1943, but most of the houses seen on the right still line Madison Avenue.

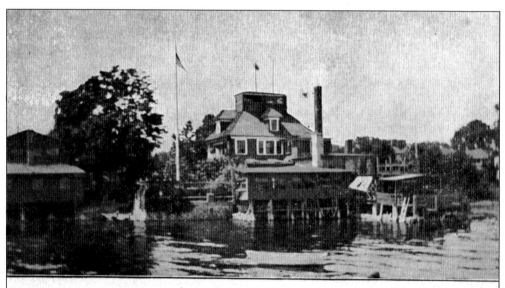

Home of Norden Singing Society, Black Rock Hardor, 4 Seabright Ave., Bridgeport, Conn.
Telephone Barnum 1430

The Norden Singing Society, an all-male chorus, was organized on November 6, 1902. Its home, built in 1906 as a print shop, is located at 4 Seabright Avenue on Black Rock Harbor. The Norden Club has occupied this building since 1924. Eventually four Swedish singing societies merged to form the SS Norden Club, and it is still going strong today.

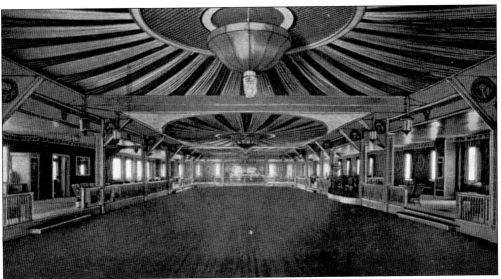

The Ritz Ballroom opened on March 31, 1923, and soon developed into one of New England's most popular dance halls. The owners previously operated the Brooklawn Pavilion dance hall on Brooklawn and Capitol Avenues. The dance floor at the Ritz came from the Brooklawn Pavilion. One of the owners, George McCormack, was issued a $50 ticket for impeding traffic while the dance floor was being moved in two pieces to the Ritz. The dance hall closed in 1961 and was then leased to Breiner's Furniture. On June 12, 1970, the furniture store caught fire and the Ritz Ballroom was completely destroyed.

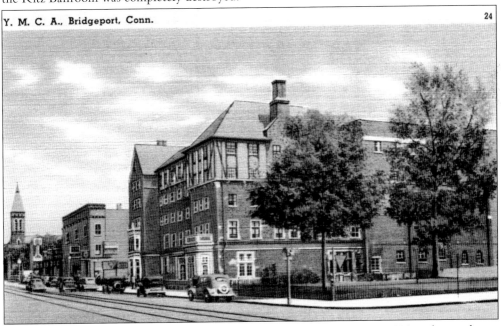

Y. M. C. A., Bridgeport, Conn. 24

The YMCA, formed in 1883, outgrew the building it called home since 1891 at the northwest corner of Main Street and Gilbert Street. The YMCA moved into a larger building in 1929, located at 651 State Street. Besides state-of-the-art sports facilities, the building contained short-stay apartments on the upper floors. This English Tudor–style building has recently gone through a complete renovation.

A beauty on the sand beach sends her greetings from Pleasure Beach in this postcard sent to a veteran's hospital in New York State on July 5, 1946. Pleasure Beach was rumored to be the location where William "Captain" Kidd buried his treasure. In fact, a statue of the famous pirate was placed near the entrance to the island around 1894. Many years later, a fire on Father's Day in 1996 ended automobile traffic to Pleasure Beach. The entire park sits abandoned and virtually inaccessible. Eventually a new bridge will be built. The entire property may be sold to the government and become a wildlife refuge.

A clown poses with a likeness of P. T. Barnum aboard a float in the great street parade. The Barnum festival has been a Bridgeport tradition since 1949. The yearly festival honors Barnum, Bridgeport's most famous citizen. Millions of people have been thrilled over the years with fireworks, parades, antique car shows, hospital visitations, drum and bugle corps competitions, air shows, ballyhoo shows, dances, dinners, balls, concerts, yacht regattas, and so on. All the events are put together by a very dedicated group of volunteers.

Nine

BIRD'S-EYE VIEWS

GENERAL VIEW OF ST. MARGARET'S SHRINE WHICH MAY BE REACHED FROM
THE MERRITT PARKWAY VIA PARK AVENUE EXIT.

St. Margaret's Shrine is located at 2539 Park Avenue, north of Capitol Avenue. Rev. Emilio Iasiello, pastor of St. Raphael's church, was inspired to build the shrine by the Japanese attack on Pearl Harbor. The shrine, built on the site of the former Columbus Park, is a monument to peace built in memory of those who lost their lives in war. The main chapel was dedicated on September 20, 1942, and constructed out of materials salvaged from the Annie Burr Jennings mansion in Fairfield. Also used in constructing the shrine were windows, doors, and lumber from former homes of the Rockefeller family, W. H. Hayes of Greenwich, and the Blair estate in Morristown, New York.

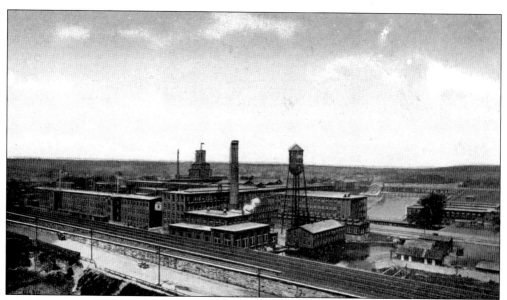

The Union Metallic Cartridge Company was incorporated in 1867, and in 1912, it merged with Remington to form the Remington Arms Company. This view is looking northwest from the Holmes and Edwards Silver Company factory building that still stands on the corner of Seaview Avenue and Crescent Avenue. The low building seen at the base of the tower was constructed over water for safety reasons in case of an explosion. Some of the buildings are still standing, including the powerhouse at the base of the large smokestack and the shot tower in the distance.

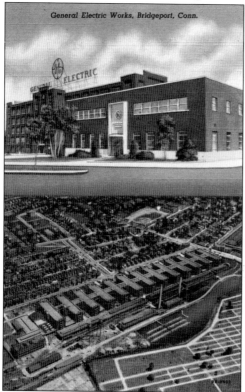

General Electric has occupied this sprawling plant since 1920. Previous to this, the plant was built for the Remington Arms Company. In the above view, the front of the building with the General Electric logo on the roof is shown on Boston Avenue. The bottom view shows the half-mile-long set of buildings as seen from the air. Lakeview Cemetery and Stillman Pond are at the bottom of the photograph. At the top, Harding High School and Hedges Stadium can be seen.

The Warner Corset Factory buildings are shown in this artist's conception from about 1909. This view is looking northwest at the corner of Atlantic Street and Lafayette Street. The original factory building was constructed in 1876 and was expanded over the years. The smaller building shown on the corner is the Seaside Institute dedicated by Pres. Grover Cleveland's wife, Frances, in 1887. This building, originally constructed for the benefit of the many single women employed by Warner's, is still standing today. Some of the original factory buildings have been converted into loft-style living space.

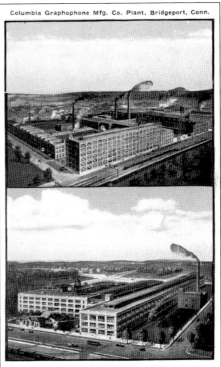

Both Columbia Phonograph Company plants are shown in this postcard view. The top photograph shows the west-end plant looking southwest at the corner of Howard Avenue and Railroad Avenue. The buildings are still standing today with the letters *c p* still visible on one of the smokestacks. The bottom photograph is looking northwest at the corner of Barnum Avenue and Summerfield Avenue. This plant was originally the home of the University of Corset's factory, and the large building on the left and a part of the larger building on the right remain standing today.

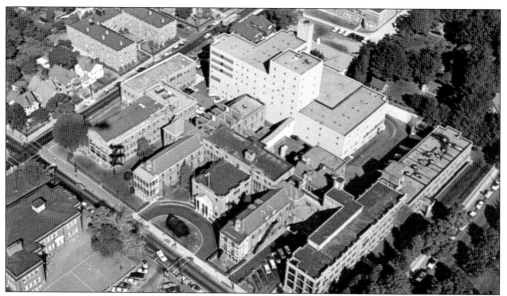

This aerial view of Bridgeport Hospital shows the additions made over the years to the original building opened in 1884, which was the U-shaped section in the center. Central Avenue is on the left, the hospital fronts on Grant Street, and Mill Hill Avenue is on the right. The brick building across the street on the left is Summerfield School. In the late 1960s, the oldest sections of the building were raised, and the present towers were built in their place, leaving some of the outer sections still standing.

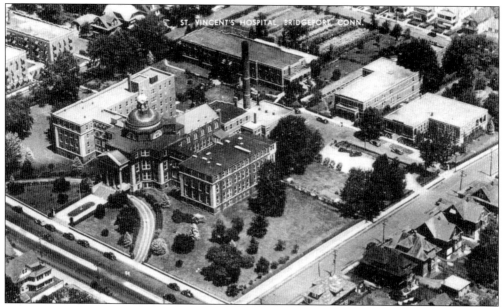

St. Vincent's hospital building, when completed in 1905, consisted only of the domed central building and the section to the right of it. This aerial view shows how this original building expanded over the years. Hunting Street runs to the left of the building, Main Street is in front, and Hawley Avenue is seen on the right. In 1976, the old buildings were torn down after the present hospital was constructed in back. At first, a parking lot replaced the original buildings until recently when a new parking garage was constructed.

The present post office and federal building was completed in 1934. Designed by local architect Charles Wellington Walker, it was constructed of limestone and was said to cost $1 million to build. This view is looking northeast along Middle Street. The house seen to the left of the post office is Dolan's Corner, originally built on Water Street and moved to the corner of Golden Hill and Middle Streets in 1871.

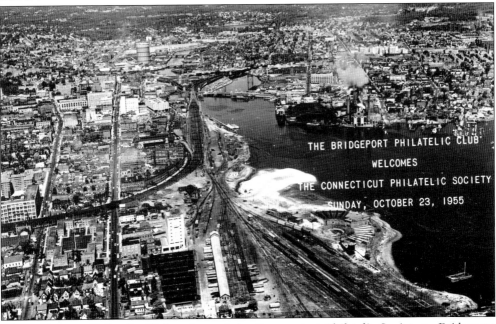

THE BRIDGEPORT PHILATELIC CLUB
WELCOMES
THE CONNECTICUT PHILATELIC SOCIETY
SUNDAY, OCTOBER 23, 1955

The Bridgeport Philatelic Club welcomed the Connecticut Philatelic Society to Bridgeport in 1955. The club members collected postage stamps, stamped envelopes, and postcards. On October 23, 1955, the day this event took place, this postcard was postmarked in Bridgeport at 10:00 a.m. and also stamped with the club logo. The aerial view is interesting since less than a year later demolition began for the construction of the Connecticut Turnpike through the city.

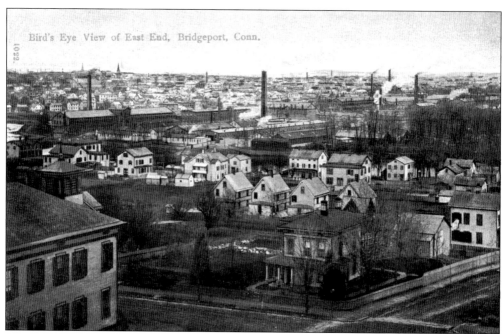

This bird's-eye view of the east end of Bridgeport was taken in 1889 from the tower of Bridgeport Hospital. The view is looking southwest at the corner of Grant Street and Mill Hill Avenue. The house on the corner was built in 1876 for George Zink and is still standing. The building on the left is the original Summerfield School constructed of wood. In the distance are the factory buildings of the Union Metallic Cartridge Company on the left, and the Wheeler and Wilson Sewing Machine Factory buildings are to the right.

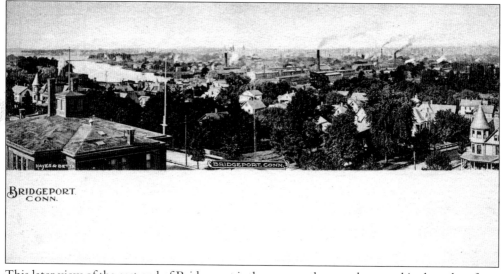

This later view of the east end of Bridgeport is the same as the one above and is also taken from the tower of Bridgeport Hospital. On the left is Summerfield School, constructed of brick in 1894, which replaced the original wooden building that burned down in 1890. The area in this view, originally called Lake Village, was developed at the time of the Civil War overlooking Pembroke Lake. The street names in this area—Grant Street, Ogden Street, Sheridan Street, Mead Street, and White Street—are all names of Civil War generals.

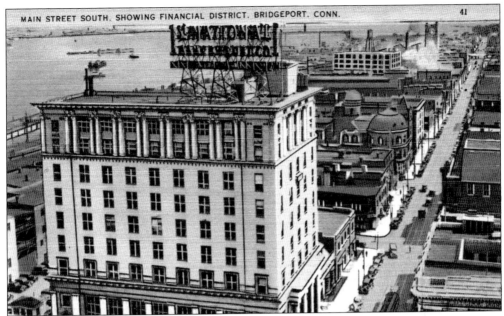

This view of Main Street is looking south from the top of the City Trust building. Prominent in this view is the First National Bank, which was the tallest building in Bridgeport until the City Trust was constructed. The Barnum Museum is easy to find thanks to its unique architecture. The factory building in the distance belongs to the Sprague Meter Company. Today the Bridgeport Center office building takes the place of the First National bank building and occupies the left-hand side of Main Street and wraps around the Barnum Museum.

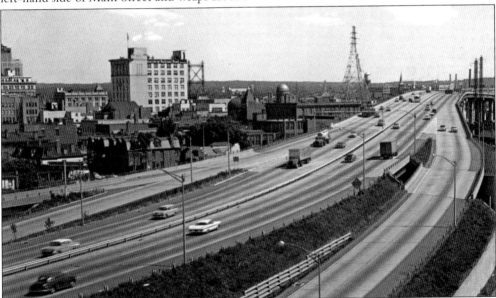

The recently opened Connecticut Turnpike winds its way through Bridgeport in this postcard from 1958. This view, looking east, shows the bridge that spans the harbor in the distance, and the northbound entrance from Lafayette Street and South Frontage Road is shown on the right. Some of the buildings on the left adjacent to the turnpike were spared demolition for this massive construction project only to be eventually torn down for urban renewal.

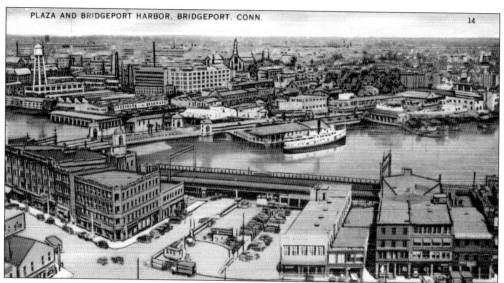

The plaza was Bridgeport's first attempt at urban renewal and was created in 1919. The area around State Street, Water Street, and Wall Street had become highly congested with many buildings very close together, most of them being run down. These buildings were demolished to create this area known as the plaza. Water Street was widened and is shown in the foreground with Wall Street on the left. Also, John Street was extended from Main Street to Water Street at this time. Today the train station is located where the buildings are seen on the right. Water Street has been rerouted and takes the place of the rest of the buildings seen on the left.

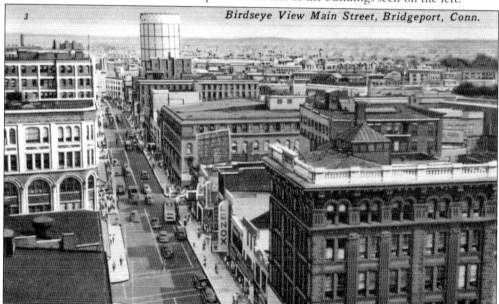

Birdseye View Main Street, Bridgeport, Conn.

This bird's-eye view of Main Street looking north was taken from the top of the City Trust building at the same time as the postcard view of Main Street looking south shown earlier. The Connecticut National Bank on the corner of Wall Street is the first building on the right. Behind the bank is the Wheeler Building on Fairfield Avenue. In the background is the storage tank for the Bridgeport Gas Company, which later became known as the Southern Connecticut Gas Company.

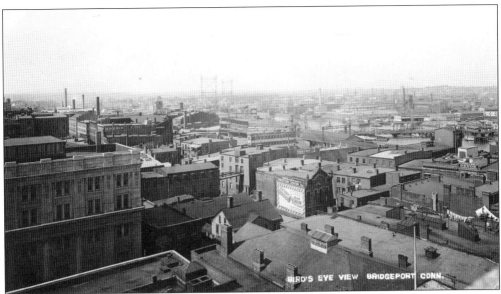

This real-photo postcard view is looking northeast from the corner of Main Street and State Street. On the left is the City Savings Bank building on the corner of Bank Street. Near the center of the photograph is the Belmont Hotel, also on Bank Street. An advertisement for Blue Ribbon Eggs is painted on the side of this building. Note the laundry hanging on the clothesline on the roof to the right. This view shows the congested area torn down as part of the plaza renewal project.

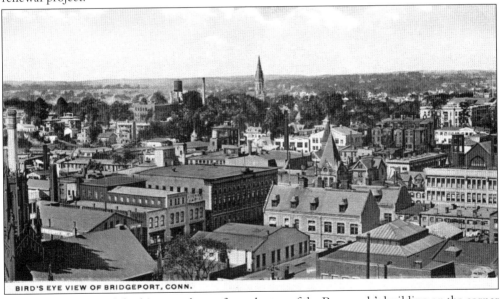

This bird's-eye view is looking northwest from the top of the Burrough's building on the corner of Main Street and John Street. Some of the buildings seen are on Broad Street, including the First Congregational Church on the left, the Hinck's and Johnson Carriage factory (Nothnagle's building) in the center, and the old post office is across the street. In the distance on the right is the new Bridgeport Central High School, and the old high school is to its left. Also on the right is the First Methodist Episcopal Church with the twin spires. In the distance is the steeple of St. Augustine's Church.

ACROSS AMERICA, PEOPLE ARE DISCOVERING SOMETHING WONDERFUL. *THEIR HERITAGE.*

Arcadia Publishing is the leading local history publisher in the United States. With more than 3,000 titles in print and hundreds of new titles released every year, Arcadia has extensive specialized experience chronicling the history of communities and celebrating America's hidden stories, bringing to life the people, places, and events from the past. To discover the history of other communities across the nation, please visit:

www.arcadiapublishing.com

Customized search tools allow you to find regional history books about the town where you grew up, the cities where your friends and family live, the town where your parents met, or even that retirement spot you've been dreaming about.